GOOD HOUSE HUNTING

20 STEPS TO YOUR DREAM HOME

GOOD HOUSE HUNTING

20 STEPS TO YOUR DREAM HOME

 DENNIS WEDLICK

WRITTEN WITH PHILIP LANGDON

HARPER
DESIGN

An Imprint of HarperCollinsPublishers

GOOD HOUSE HUNTING: 20 STEPS TO YOUR DREAM HOME

Copyright © 2005 by Dennis Wedlick

First published in 2005 by:
Harper Design,
An Imprint of HarperCollins*Publishers*
10 East 53rd Street
New York, NY 10022
Tel: (212) 207-7000
Fax: (212) 207-7654
HarperDesign@harpercollins.com
www.harpercollins.com

Distributed throughout the world by:
HarperCollins International
10 East 53rd Street
New York, NY 10022
Fax: (212) 207-7654

HarperCollins books may be purchased for educational,
business, or sales promotional use.
For information, please write:
Special Markets Department, HarperCollins Publishers Inc.,
10 East 53rd Street, New York, NY 10022.

Design: Wayne-William Creative, Inc.

Library of Congress Cataloging-in-Publication Data

Wedlick, Dennis.
 Good house hunting : 20 steps to your dream home /
by Dennis Wedlick.— 1st ed.
 p. cm.
 ISBN 0-06-077995-0 (pbk. with flaps)
 1. House buying—Handbooks, manuals, etc. I. Title: 20
steps to your dream home. II. Title.
 TH4817.5.W43 2005
 643'.12—dc22 2004029896

First Edition

Printed in China

1 2 3 4 5 6 7 / 11 10 09 08 07 06 05

First Printing, 2005

I would like to acknowledge all of the help I received from

Andy Brown
Alison Hagge
Chris Hunt
Jessica Olshen
Harriet Pierce
James Pittman
Marta Schooler

and of course my co-author, Philip Langdon, for all of his
hard work and care.

Photography Credits:

Elliott Kaufman—TOC, 28–29, 30, 32 (top, bottom), 36,
38, 40, 51, 74, 80, 86 (top, middle), 88 (top, bottom),
100, 116, 118 (top, bottom), 122–123, 124, 126 (top,
bottom)

Jeff Goldberg/ESTO—cover, 2, 7, 9, 15, 19, 20, 46, 48, 50,
54, 57, 58, 60–61, 62, 64, 68, 71, 76, 78, 82, 104, 106,
108, 110, 112 (top, bottom), 130, 134, 136, 140, 142, 149

Peter Aaron/ESTO—72, 92–93, 94, 96, 103

Michael Fredericks—42, 146

Andrew Lindy—Dennis Wedlick portrait on back flap

20 STEPS TO YOUR DREAM HOME

Step 1 Establish a price range for the property that leaves enough money to realize your personal vision of the dream home; buy less of a home and do more with it.

Step 2 With wish list in hand or head, consider every location (in your price range), including your current one; keep an open mind.

Step 3 Check potential locations often, during the full course of the day, week, and even the seasons if possible.

Step 4 Practice envisioning yourself—your possessions and your dreams—in places you are considering for locations.

Step 5 Narrow your favorite locations to two or three and never fixate on one; commit your heart to a location only when it is yours to keep.

Step 6 Estimate the value of the home through comparables, replacement cost, and its unique features.

Step 7 Never judge a house by its "curb appeal." Look for pleasing proportions, an appealing setting, and quality construction.

Step 8 Recognize that good homes have interiors that look comfortable and attractive, even without a stick of furniture in them.

Step 9 A home is just as much a machine as an automobile. You need to check the mechanical systems.

Step 10 Make three lists: what you like about the house you're considering buying, what you would hope to change about it, and what you dislike that cannot be altered.

Step 11 Never give up on the dream. Revisit all your wishes, and plan some way to satisfy the essence of each of them.

Step 12 Be methodical; consider every surface and corner of the home, and, piece by piece, plan on personalizing it with your own touch.

Step 13 Understand that the best return on improvements to a home comes from making the good points even better— inside, outside, and in the landscape.

Step 14 Consider strategic little changes that can go a long way toward turning a good home into one that's just perfect.

Step 15 Know the local property laws, your property's limitations, and your obligations before you close on a home.

Step 16 Building, renovating, or repairing a home can be hard. Stay in control with realistic expectations, a steady focus, and a bright outlook.

Step 17 Realize that a total makeover can be expensive but the results can be even better than starting from scratch.

Step 18 A healthy home is a happy home; beware of the hazards of indoor air pollution and unsafe conditions.

Step 19 Learn the rules and restrictions imposed by the government and other authorities.

Step 20 Remember that a dream home will take time, patience, and hard work; but it is a proven financial and emotional investment.

CONTENTS

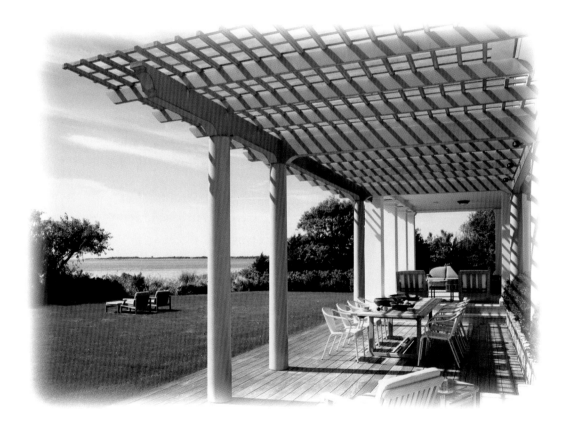

PART ONE

DREAM HOME PLANNING

"There is no place like home."

Who doesn't wish for the perfect place to live? We all yearn for a home that stirs our emotions. It may be a big old farmhouse in green countryside, it may be a tiny studio apartment in the city, or it may be something else entirely. Whatever its character, there is, without doubt, some residence that embodies our aspirations. A good house reflects who we are. It's like a second skin. It is, in other words, a dream home. To capture that sought-after quality—first in one's mind and then in material form—can bring harmony to a person's life. Too often we hesitate to focus on our needs and aspirations for fear of being unable to fulfill them; but there are so many places to live and so many ways to make a place feel like home, that there's a good chance the essentials of one's dream home can be realized. Close your eyes for a moment and see if you can envision what your own dream home would be, for this is the first step in making it come true. Careful planning and smart choices make the essence of the dream attainable, no matter what the budget.

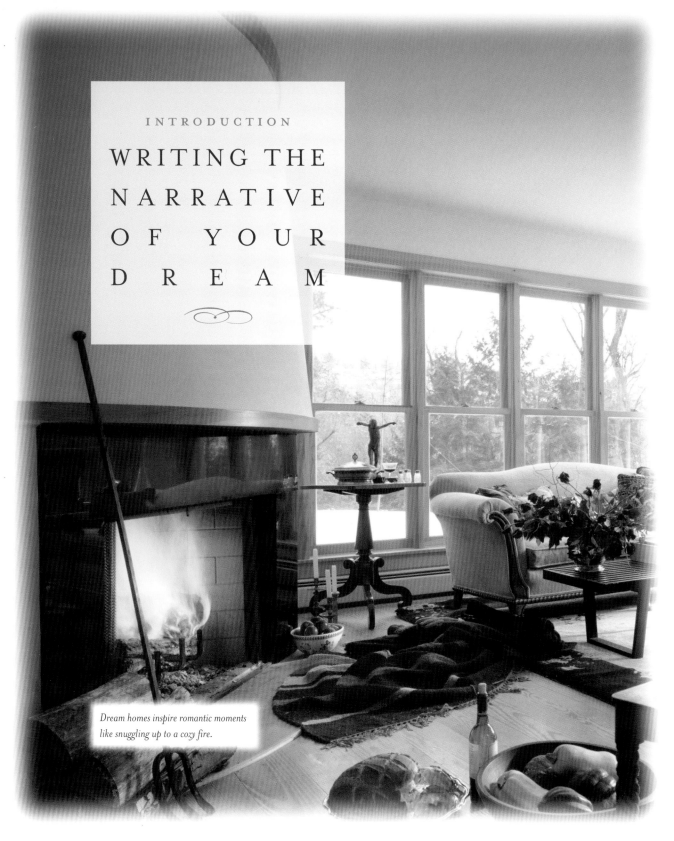

WRITING THE NARRATIVE OF YOUR DREAM

Dream homes inspire romantic moments like snuggling up to a cozy fire.

Many of the qualities that make a well built, practical, and healthy home are recognized universally. Yet the ideal home remains to a large extent a matter of individual tastes and desires. One kind of house does not satisfy everyone, any more than one size of clothing truly fits all. What most of us want is a house that reflects our own personal vision. This is the kind of dwelling that's a treasure to live in because it embodies qualities we hold dear. The better we can define ourselves, the better chance we have of discovering the home that suits us best. For this reason, hunting for the dream home must be in good measure a creative process, like finding the words to write a personal story. Research and deft house design techniques will make for a better result. But it must begin with a personal search.

Personal Vision

As a residential architect, I often have people come to me with a piece of land or a house they own that they would like to develop into their ideal place to live. I also get many people who want me to help them find the property that has the most potential for fulfilling their aspirations. Either way, the best results flow from a creative process beginning not out in the world of real estate but within the worlds of my clients' imaginations. The first thing we must hunt down is what the dream home means to them. Success in finding a dream property lies in people's willingness and ability to work their imagination and thus define what kind of home would be ideal for their lives. This amounts to a personal vision of the dream home. Such a vision includes what would best suit their likes and dislikes, their aspirations and inspirations, and what would make their daily lives more convenient and pleasant.

A vision of the dream home is dynamic. It changes according to location (the ideal home in a small town in Vermont versus the perfect cabin in the Rocky Mountains), according to immediate needs (the ideal apartment near a job in an urban center, versus the perfect bungalow at the beach), and according to time of life (the perfect home for a growing family versus the ideal retirement home). Each of us has a sense of the one-of-a-kind place where we would feel most at ease, most secure, most happy. We may not have had a chance to consider it fully, and even if we have, it is often

Each of us has a sense of the one-of-a-kind place where we would feel most at ease, most secure, most happy. We may not have had a chance to consider it fully, and even if we have, it is often not easy to bring it into focus.

not easy to bring it into focus. Nonetheless, a vision of the dream home is there. It is made up essentially of those thoughts of home that bring a smile to our face, that represent life being a little easier, and that inspire us. By listing or describing those thoughts, you can formulate and express the vision without literally drawing a picture of it. Not many clients are skilled at drawing, but nearly all can, with some effort, write a narrative of their dream home. This written picture is an effective tool, as effective as an illustration.

The Heartfelt Essentials

Coming up with a narrative or a vision may seem a daunting task. Many people will claim they have no imagination, that they cannot envision things before seeing them firsthand. But whether someone is the obviously creative type or not, his or her mind actually abounds with thoughts of home. And just as people do when searching a pantry for ingredients with which to make a dinner, clients can round up disparate thoughts and use them. Those thoughts are the ingredients in a personal recipe of the ideal place to live.

There is no need to try to imagine exactly what the dream home would look like; that will fall into place over time. All that's required is an effort to gather your thoughts on how you move through your everyday life. What is it you do first thing in the morning, and how might your home make the morning routine most organized or enjoyable? Morning may be the most important time of day for you. I had a client who had wished for a home containing a comfortable, special place where she could go through her mail, have her coffee, and read the paper in the morning light, right off the kitchen. A desire like this is exactly what dream homes are made of.

Perhaps more important than anything else is the act of recognizing what will make us happy. A person needs to have a clear understanding, a vision, of his or her own dream home, even if it applies only in a particular place and at a particular time. This vision is needed before advice about buying, renting, building, or renovating will provide any real benefit.

A multimillionaire's mansion high on a hill might at first seem the dream place to live. But down deep, few people long for such a place. A lavish, expensively appointed house

There is no need to try to imagine exactly what the dream home would look like; that will fall into place over time. All that's required is an effort to gather your thoughts on how you move through your everyday life.

does not necessarily have the qualities that make us feel comfortable. In fact, for many people, life may seem most romantic, or most efficient, in a simple home, one that's small and compact. Conversely, for people who use their home for most of their work, for play, and for extensive entertaining, a minimalist cottage might not be right. People's needs vary greatly, and so do their dream homes. A dream home is not something that can be mass-produced. It differs from person to person and must be tailored to the character of its inhabitants.

A Personal Formula

Bookstores and libraries contain plenty of architecture and interior design books that dispense sound advice on principles of house design. Some of these books present floor plans; the great majority competently instruct readers on the basic criteria for good houses: that the houses are efficient and organized, that they are in tune with their surroundings, that they supply adequate fresh air, and so on. Useful though such books are, they do not offer a formula that anyone and everyone can use. Nor should they. The essentials of a dream home have to do less with universal prescriptions than with individual desires. Creating a dream house depends on the occupants—their loves, their preferences, their idiosyncrasies.

One client of mine bought property with the idea of building a new home and asked me if it was all right to have both a grand foyer with a large front door and an equally large informal back foyer in the house she was planning to build. She had read in a book that since few people use the front door, dedicating an equal amount of space to both entryways was inefficient. She agreed with the book's observation about the limited use of the front foyer—in her current home, family and friends rarely went to the front door, preferring to come through the back—but the front foyer nonetheless seemed essential: a welcoming place for strangers and neighbors, and an expression of formality that, for her, added to the quality of the home. She had an emotional and romantic attachment to this space and could not bear to envision a dream home without it. Her instincts were right, of course. In a dream home, you must include heartfelt desires, even if some people might consider them unnecessary.

The essentials of a dream home have to do less with universal prescriptions than with individual desires. Creating a dream house depends on the occupants—their loves, their preferences, their idiosyncrasies.

One of a Kind

I have met people whose notion of the dream home at first seemed a perfect fit with historic archetypes such as a New England center hall Colonial or a rustic log cabin. But once they began to be more introspective about their lives and aspirations, they disclosed details that ended up taking them toward something subtly different. The classic models served as useful starting points, but along the way, it became apparent that some departures would make sense—modifications that would lead to a unique home reflecting its owners. A dream home may depart only slightly from other houses and yet have enough individuality to be deeply pleasing. For house hunters, this is good news. It suggests that looking at existing houses is productive. Even what are described as "cookie-cutter" houses may have the potential, in the right locale or circumstance, to be transformed into distinctive residences. Various touches might be added to express the buyers' personalities and turn a common house into something close to ideal. Once you have identified the essentials of your dream home, a designer can help infuse those qualities into an existing house.

If an existing house won't do, that will become clear soon enough. Perhaps your vision of the dream home is unlike any house that has ever been built. It's been my experience that the more fantastic the dream, the better the results usually turn out to be. Every wish can be acted upon in a home. Though real estate brokers often discourage people from pursuing unique visions, because they assume that one-of-a-kind homes are hard to sell, I believe a home can both realize a personal fantasy and command a high resale price—if it is well built and thoughtfully designed. Just as with people, homes that have character can stand out from the crowd in a positive way. The character must spring from an inspiration, preferably from one based on the wishes and personalities of its occupants.

The Narrative

I have had the pleasure of speaking with people who have achieved success in every aspect of life, yet who lack confidence in their ability to describe their ideal place to live. Even the smartest of clients may assume they lack the skills

A dream home may depart only slightly from other houses and yet have enough individuality to be deeply pleasing. For house hunters, this is good news.

with which to write a portrayal of their own dream home. They are laboring under a misapprehension; the fact is, house hunters need not be trained as architects, interior designers, brokers, or builders to know what would bring them happiness. The future occupants are the best guides to what should be done.

The seeds of the dream home are a collection of the house hunters' thoughts, which, believe it or not, will eventually come together like pieces of a puzzle. The thoughts will take the form of what I like to call a narrative—the story of what makes a satisfying place for you and for your activities. Such a narrative includes general statements and it includes details as well. It conveys the feelings you associate with living in the ideal home, or the impression the home might make on someone else. The narrative can draw on any or all of the senses; I've known clients who found great pleasure in the scents and smells of cooking, the sounds of a creek, lake, or ocean, the textures of wood or exposed brick, the brilliance of natural sunlight. The description of your ideal place may seize on memories of places you have visited or imagery from places you've seen in the movies. It should include all of the things that make a home comfortable, secure, and attractive for you.

Some house hunters make their narratives tightly organized. Others string sentiments loosely together or make their stories stylish. Some describe their dream homes in the simplest terms, for they long to live in houses embodying simplicity. Still others make the narratives impressive. There is no right or wrong way of describing the ideal place to live. Each person has an individual approach. Even if a homebuyer's preferences seem to match a particular type of home, such as a simple saltbox or an industrial loft, the homebuyer may transcend such common labels by the end of the process, when numerous additional attributes have been identified. A person's dream home requires a thorough and individualized narrative. As an architect, it is my job to help clients come up with it. The hardest part of my job is convincing people that they indeed have a unique story to tell about their dream home.

A tranquil view to inspire writing may be part of the dream home.

Once they begin, they realize how individual their vision is, and how individual they themselves are—which helps me to pursue their quest. It also magnifies the pleasure I get from the project.

The Method

When new clients come into my office, what I do to start them on their personal narrative is ask a few carefully considered questions—questions that have no right or wrong answers but that will give them an indication of how to begin exploring their own notions of the ideal place to live. The questions from me are intended only to get them started. Soon they will make what should be a surprisingly satisfying journey through their own impressions and emotions, defining themselves and their desires. Over the years, I have learned that if I stick to a preselected series of questions about the dream home, people will be inhibited from doing what's most important: reaching deep within themselves to understand what would offer the most satisfaction. There is no one framework for defining the dream home that will suit every individual, but it is possible to be methodical and comprehensive. I might ask people who are looking at land, "Do you prefer a home that is perched on a hill, or nestled into the woods?" If the clients are adding a master bedroom and have the choice of placing it on an exposed side of the house or on a more isolated corner, I might ask, "Do you like a bedroom with expansive views, or a more secluded one?" With clients who are thinking of renovating an apartment, I might inquire whether they prefer more open floor space or more closed storage space. These are the kinds of questions I sometimes ask that relate to the clients' specific needs.

Some people begin thinking about a dream home when they are ready to move or are ready to alter their current home. Others start dreaming long before there is any chance of acting upon their yearnings. I am of the opinion it is never too early to start dreaming. If people are not at the point of making a move, renovating, or building a new house, and they are interested in discovering what and where their ideal place to live may be, it can be helpful to engage in this creative process as if they had arrived at that very point. Acting as if a change is imminent will help bring the vision to a realistic resolution.

}

Over the years, I have learned that if I stick to a preselected series of questions about the dream home, people will be inhibited from doing what's most important: reaching deep within themselves to understand what would offer the most satisfaction.

{

WHAT DREAMS ARE MADE OF

In putting together a narrative of your dream home, you should find words that describe both the practical and the romantic ingredients that would make a residence ideal. Random thoughts are fine. They provide useful clues to what the dream house should offer. List your thoughts about how the house would function, what it would look like, what it would feel like to be around it and inside it. The list could include references to homes and spaces you've seen and admired in magazines and books or that you've personally visited, whether they were the homes of friends, family, or neighbors or spaces you encountered on vacation trips: a great hotel room, the fireplace corner of a lobby, the shower at a spa. You might mention favorite places such as a public garden, a contemplative respite in a busy city, a niche you love in a restaurant. The dream home can incorporate things that make those places convenient, inspiring, or special.

The list might include references to places where you've lived in the past. At an early age we become aware of the qualities of our homes, noticing when rooms are bright or dark, cold or hot, comfortable and cozy or intimidating. I have found that childhood experiences of home have a big impact on people's desires in a dream home. These thoughts should not be ignored or glossed over, for they are powerfully connected to a person's development. The list should include things that the house hunters associate with negative feelings, because you want to identify what a home should not be as well as what it should be. A bad experience in a home is difficult to overcome. If a Colonial interior reminds

A luxurious bath may be one with a view of the stars.

someone of a disturbing episode, even the slightest touch of a Colonial décor can ruin an otherwise wonderful home. What may seem a warm and comfy little room for one person may remind another of a claustrophobic experience. Large spaces with lots of glass to take in a view might strike some people as too exposed, bringing on a feeling of insecurity no matter how beautiful the view. Listing these thoughts—"small rooms make me feel uncomfortable," "too many windows make me feel unsafe"—helps to create a complete guide into home discovery and avoids such pitfalls.

Wish Lists

Designers often refer to this list as a "wish list," for it compiles all the wishes a person has. To assemble the narrative, you may use paper and pen, keyboard and screen, typewriter, or whatever works for you. It is not enough to simply think up a list of wishes and not bother to write them down. There is no need, however, to try to draw the dream home or look for a near-perfect plan in a plan book. (You can put aside all those plans you've clipped over the years.) There is no need to try to find a house or an apartment that is similar, or to circle the ideal location on a map. You must write your thoughts down, for a written list is the most effective document for identifying your ideal. A written wish list is like a treasure map. A few notes on a sheet of paper, no matter how cryptic, will lead the treasure hunter directly to the goal, once he or she knows how to read them.

Without a list, it is far more difficult to find the treasure. I emphasize this because the degree of resistance I have received when asking clients to write a wish list has often amazed me. If people do not take the time or make the commitment to write something down, they make their search much more laborious than necessary—or worse, they never accomplish their dreams. There is no need for me—or anyone, for that matter—to describe what needs to be on the list. The list cannot be too short or too long. Even if the list is but a few sentences at first, it will highlight a person's priorities and considerations. Keep in mind that this is only the first step in the creative process that will ultimately determine the dream home. A person may return to the clippings and sketches he or she may have compiled in the past, but

If people do not take the time or make the commitment to write something down, they make their search much more laborious than necessary—or worse, they never accomplish their dreams.

WISH LIST

LEARN FROM THESE EXAMPLES

Whether our clients seek our advice on buying a property, renovating an existing structure, or building a new home, we always suggest that they first write a detailed wish list that outlines their most heart-felt desires.

HIS WISH LIST

The feel of the home should be timeless and should have character. I like peaked roofs and stone.

When you walk into a room, you should feel personality that is unique for the purpose of the room. People must see and feel a sense of what we are about.

I would like an area to display my music collection of twelve-inch albums.

I like fish and have a seventy-gallon tank that I am not currently using.

I like to cook and entertain. I would like a kitchen that functions better while guests are in the house.

HER WISH LIST

The house should rise from the ground as if it deserves to be there (somewhat majestically), and be a part of the beautiful terrain; it currently looks as if it just "plopped" on the earth.

I would like an impressive, romantic foyer, hallway, and stairway in the front of the home. Hallways should lead you to another area, not just be passageways.

I would like a dining area for just us and an area to accommodate larger gatherings. The area should connect to the outside, possibly by a window that opens up to the outdoors (need nice scenery to look at).

I'd like a better kitchen layout. No traps. Guests trap us near the sink and we can't get out.

I'd like the master bedroom to be private and away from all else, especially noise.

Need one area, possibly connected to stairs, for "office" with lots of light, but also a very quiet retreat accessible to all family members. Should be almost meditative.

WISH LIST
CREATE YOUR OWN

A dream home accomplishes the most important needs and aspirations of its owners. A wish list for the dream home need not follow any particular structure, for it is through a collection of random thoughts that a person's priorities are revealed. However, sometimes people do not know where to begin. The following are questions that might help you to create your wish list:

- How would the dream home make your daily routine more efficient? More organized? More fun?

- How would the dream home be a reflection of your taste? Your personality?

- What aspects of other homes that you have lived in would you like to repeat in your dream home?

- What memories of other homes that you have lived in or admired would you like to have reflected in your dream home?

- How would the dream home make you feel more comfortable? More secure? More at ease? What features would it include to do so?

- How would your dream home best suit your preferred location? Would it have the feeling of a hideaway? Or is it a welcoming gathering place?

- How would the dream home help you to have visitors more easily?

- How would your dream home best accommodate your guests? Those who come for a short stay, and those who stay overnight?

- How would the dream home better accommodate your recreation needs and home entertainment needs?

- How would the dream home better accommodate the storage needs for your clothing and linens? For your paperwork? For your seasonal equipment and decoration? For your travel and leisure? For your tools and craft supplies? For all your personal items?

- How would your dream home meet your future needs? As your family grows or shrinks? As you have more resources to invest in it? When you retire?

- What do you hate and would never want in a dream home?

- What have you always wanted in each and every room of a dream home? In the landscape? In the neighborhood?

that's after having produced a list—typically one that comes off the top of your head in the course of a few hours or a day. There is no need to worry about the order of the wishes, nor is there a need to write the list more than once to give the wishes an order; they should be jotted down as they come to mind. Over time, as the list is contemplated, the importance of what's on it and what's not will be revealed.

Free Thinking

The wish list is also the most personal part of the hunt for the dream home. When there is more than one person in the household, each of them must make his or her own list. The reason for this will become apparent as the process goes on. Basically, the list is not valid if it is written with someone else or written by one person for another member of the household. When a couple, or a family has so much in common and share the same basic values, it may be hard to understand why a collective list would be a problem, but believe me, the individuals in a household will not want all the same things. Experience with hundreds of loving families has shown that no two lists will be exactly alike, even in the most harmonious family. Children, too, should be given the opportunity to compile their own lists. If they are too young to read and write, they may dictate them. Their lists, like those of anyone else, should not be edited before they have had chance to hit the paper. There will be plenty of time to clarify, develop, test. It is the raw, free-thinking wish list that is the most fertile ground on which build a dream. Should any filter be put on the initial list, the most valuable thoughts may be left behind in the filter. Differences in the lists help lead the family to a home that is as close as possible to ideal for all of them.

The wish list leads the way not only to the dream apartment, house, or family compound; it also leads the way into the minds and hearts of those who will live there. Each word or phrase on the list is linked in some way to thoughts about how you live or would like to live, your memories of home, your flights of imagination, and the way you feel about those you live with. The best way to get a sense of how to write such a list is to simply take a stab at it, in full confidence that it can be discarded and started again. Sometimes people's first ideas of what their dream home might be are limited not by

The wish list leads the way not only to the dream apartment, house, or family compound; it also leads the way into the minds and hearts of those who will live there.

what they feel they can afford or deserve but simply by not having had an occasion to think about it. Putting your mind through the exercise of dreaming will increase the strength of your imagination, which in turn will increase the opportunities for discovering the dream home.

Testing and Developing the Vision

Each step in writing a personal narrative of the dream home needs to be followed by a pragmatic one, that of getting the most value out of the self-exploration. Aspirations gain momentum when paired with the facts of the person's life, such as the financial resources available, characteristics of the neighborhoods and landscapes they have chosen, and the amount of energy and effort they are willing to invest. This pairing brings more motivational power into play. It is the back and forth between the imaginative exercises and a reality test that will help shape the dream into a sound, sensible plan.

Many lessons on design, construction, and costs must be learned before you will be fully equipped to hunt down the ideal place to live. But "to dream" must come first. What follows is a "round robin" process. In other words, the vision of the dream home should be conceived, developed, tested, and then reconceived as many times as is necessary, until all the details come into focus and the bugs are worked out of the plan.

Knowing that there will be future steps, gradually leading to a practical and doable plan, should encourage the dreamer to think freely. Even the wildest, most far-fetched ideas deserve a chance to be considered, developed, and tested. Dreaming doesn't cost anything, and taking the time to dream allows a house hunter to buy and build wisely. Besides, I have found that aspirations are sometimes not so out of reach as people think. Ideas that may not be fulfilled immediately may still be worth considering, since you may be able to act upon them in the future. Keep in mind that a vision of the dream home is not static. The more you work on it, the more it evolves. During the process, you will invariably gain some insights into yourself and others, so the vision will mature along the way. Trial and error during the creative process enables you to discard bad choices before they have a chance to be acted upon.

Dreaming doesn't cost anything, and taking the time to dream allows a house hunter to buy and build wisely. Besides, I have found that aspirations are sometimes not so out of reach as people think.

The first stab at compiling a wish list rarely manages to identify all the functional needs that the house should serve. So many things are needed for daily life that it's impossible to recall every one of them at the start. This is no reason for worry, since the primary purpose of the wish list is simply to bring to the surface a person's aspirations. As a second step, though, you will fill out the wish list with thoughts about practical matters—for instance, the desire for a place for washing and folding clothes, a laundry chute, a drying rack, or a clothes line. Ironically, the smallest, most overlooked spaces, such as a linen closet, a handy place for a broom, or a shelf where you can drop your keys, are the ones that do the most to make a home practical. Storage should be provided for items in everyday use and for things that are needed seasonally or objects that have to be kept permanently. A home will never be ideal if it is impractical. A wish list should be amplified with things that suit everyday needs.

Dramatic spaces such as double-height living rooms or spacious bedroom suites will be better if they are easy to maintain. This means specifying surfaces that fit the homeowner's lifestyle. The specific materials and designs will vary, depending on who lives in the house. In a living room, for example, yellow pine floors look beautiful and have the virtue of being easy to clean. But if there is a large dog in the house, the pine will soon be heavily scratched, and the marred surface will trap dirt and dust just as a carpet does. The design should take into account the habits of those who live in the house. Do the owners cook, order in, or mostly eat out? Do they wear heavy boots or mostly dress shoes? The location and climate help determine what's practical and what's not.

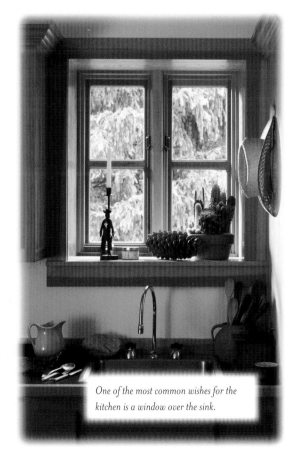

One of the most common wishes for the kitchen is a window over the sink.

Household Cleaning and Storage

Laundry rooms, linen and broom closets, and mud rooms are not the sorts of things that people brag about in real estate ads, but a house that's well equipped with work features like these is great to find. People say there can never be too much storage, which may be true, but having the right amount of storage in the right place is better than having a lot of storage in a spot that's hard to use. Similarly, a large laundry room might seem a dream—lined with shelves, with space enough for an ironing board, and with a good folding surface—but it will never be appreciated if it is on the wrong floor of the house. It ought to be on the floor you consider most comfortable for doing laundry. Think about how to adapt storage and work rooms to your habits and preferences. Personalizing a new home by adding built-in storage, fitting out a closet, or expanding or relocating a laundry room can be extraordinarily satisfying.

It may not be possible to buy an existing house that meets every one of your cleaning and storage preferences, but it's worth knowing what your preferences are. This will help you in choosing a house, approaching a renovation, or building a new home from scratch. The more thought you give to potential wear and tear, the bigger chance you'll have of avoiding a house with serious flaws. I often recommend to clients that they keep a cleaning and storage journal for a week. It is surprising how important this aspect of home life is for each family member. Thinking about this will spur you to notice which surfaces and areas are the hardest or easiest to clean. Yet another benefit of thinking about practical and maintenance issues is that it discourages the temptation to choose too large a house—one of the most common mistakes in house hunting.

The Many-faceted Kitchen

The kitchen is the hub of most homes. It may serve as a communication center, visitor center, home office, and medical facility, not to mention focal point for countless other pursuits. Because of its many activities, the kitchen has to be designed as much more than a place for cooking a meal. The wish list should include everything that figures in your notion of the ideal kitchen. For a person who cooks infrequently or for the chef who likes to have everything within

People say there can never be too much storage, which may be true, but having the right amount of storage in the right place is better than having a lot of storage in a spot that's hard to use.

arm's reach, a small kitchen may be perfect. For those who love to cook, it's important to have an efficient layout, crafted to the ergonomics of the principal users (for example, a dishwasher on the right for right-handed people). The kitchen should be easy to clean and should offer excellent storage. Itemizing all the particulars of a dream kitchen is not only helpful for house hunting; it can also be incredibly fun. The kitchen may be the showiest room in the house, with professional-grade appliances, luxurious stone surfaces, and beautiful built-in cabinetry. Even if the family rarely cooks a meal there, it may make perfect sense to fit it out to the nines, since it's often the preferred place for entertaining friends and family. Why shouldn't it be ample and well equipped? Nearly all other entertainment and living spaces should have a good connection to the kitchen. A dining space, a family room, a laundry area, or a home office can be more effectively used if it is convenient to the kitchen.

There are countless options for kitchen materials and finishes. Kitchen floors get more foot traffic than any other surface in the house; the kitchen walls confront lots of grit and grime; and the kitchen furniture, from cabinetry to the counter tops, is heavily used. So be aware that if a kitchen is built from inferior materials, it will have a short life span and be difficult to maintain. A house with a great kitchen is a valuable find.

Places for Leisure

When imagining the dream home, remember that high-quality leisure time is an important part of a satisfying life. A good home lets its occupants efficiently enjoy the activities they find most relaxing. Clients of mine are often surprised when one of the first questions I ask after they write up their wish lists is where they like to watch TV. For people who enjoy television, the dream home should accommodate that activity in more than just the designated TV room. TV, of course, is only part of the package. An ideal space to listen to music, to read, to play games—this may be part of the goal. A cozy window seat for writing in a diary, a place offering a sense of seclusion, may be what some individuals need. For someone else, a comfortable spot for watching a movie is what makes a home feel like a castle.

For those who love to cook, it's important to have an efficient layout, crafted to the ergonomics of the principal users (for example, a dishwasher on the right for right-handed people).

In searching for a house, every entertainment and leisure need should be considered. People often dream of being involved in crafts, artwork, and hobbies, yet fail to follow through. The good home inspires its occupants to live the life they aspire to by providing the ideal setting for their goals. Rooms with good storage and the right kind of space are extremely helpful for hobbies, crafts, and arts. Unfortunately, crafts are commonly relegated to unfinished spaces such as garages, basements, and attics, causing many people to spend most of their leisure time in uncomfortable surroundings while the more pleasant rooms "for company," such as a formal dining room, go unused. Imagining the leisure activities one might pursue if one had a good home provides the sorts of thoughts that should be part of the wish list. One client of mine built a new home for retirement with an entire wing dedicated to a model railroad collection. That inspired his wife to seek her own dedicated space for painting and a separate area for writing. They both now enjoy hobbies and crafts they had no time or space for when younger, and they do so in wonderful spaces filled with natural light and views.

Rarely do homes come with entertainment systems in place, but some are better equipped to entertain than others. Built-in storage for electronic equipment or shelving for books and games is often advantageous. Note that a house may be spacious, but may waste room on areas that will get little use, while being short on needed areas for entertainment. In general, watch for spaces that are designed to be well used, not just to look good.

MAXIMIZING
CREATIVE
RESOURCES

Pursuit of the dream home is most successful when people take advantage of all the available creative resources. The house hunters themselves are the primary resource. By writing wish lists, exploring functional needs, considering both the immediate and the long-term, and refining their vision, all of the household members can contribute to the creative process. Home design books and magazines offer many ideas and examples that will stimulate the search.

Professionals can be enlisted to help. There is no one answer to the question of what is the ideal place to live, so the more research you do, the better your hunt will go.

The Household Team

When more than one person is to share a home, it's best to consider the household as a team and to make each person's involvement in the planning as enjoyable as possible. Each individual has strengths and weaknesses, so take advantage of the strengths and invest time and patience to avoid being set back by the weaknesses. One person may be best at envisioning what the house, or part of it, would look, feel, or sound like without having experienced it. The household should trust this person's instincts. In turn, that person must take the time to describe, as accurately and fully as possible, what he or she foresees. An individual with a talent for envisioning may be able to enter an unfurnished house and sense whether the spaces are the right sizes to accommodate everyone's desires. Another household member may be adept at keeping the big picture in mind—balancing the financial limitations, the practical issues, and the family's aspirations. A third person may have a knack for focusing on or remembering details of numerous houses, recalling where the linen the closet was, what type of windows the rooms had, or whether there was a clever way of laying out a room. If the team is to maximize its personal resources, each team member's talents must be recognized and capitalized upon.

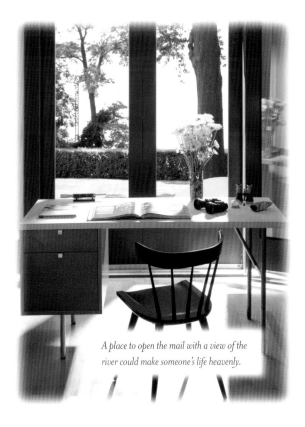

A place to open the mail with a view of the river could make someone's life heavenly.

The best teamwork allows each individual to hold onto his or her own aspirations while at the same time helping others achieve what is dear to them. I firmly believe that in every case, a house with the potential to satisfy everyone can be found if sufficient time, effort, and teamwork are applied to the preparation. Learning to listen is a cardinal requirement. I have found that the easiest way to foster constructive dialogue

When one person tries to control the outcome of the search, both the team and the results will suffer.

within the household is to allow everyone equal time to speak his or her mind without fear of disruption. Having everyone write separate wish lists is an example of giving each person a format for being heard. Listening to what a family member says to someone else can also help the process. For example, ask each person to briefly explain to someone else his or her take on a visit to a potential property or to someone's home, what the best aspects of living there would be, and what the potential problems would be. When one person tries to control the outcome of the search, both the team and the results will suffer. No place will be ideal if a household member was tricked into believing that a dream home goal was something it was not.

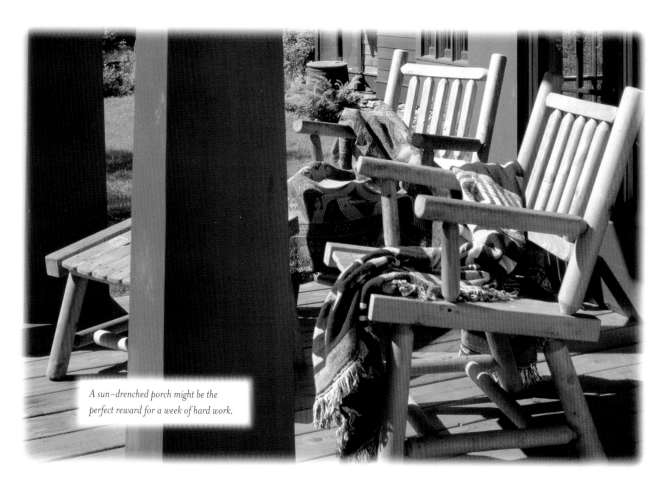

A sun-drenched porch might be the perfect reward for a week of hard work.

Architects, Interior Designers, and Other Consultants

House hunters invest a substantial sum of money in a dream home, and should recognize that professional advice may be well worth some added expense. The professionals likely to be the most useful are residential architects—individuals who dedicate themselves to helping people discover and realize their aspirations in a house. Besides the skills that residential architects can call upon within their own firms, they can also collaborate with specialists, such as kitchen, lighting, audio/visual, acoustical, mechanical, and structural designers, to make certain that every detail is right. It is rare to employ a full panoply of consultants on an affordable home, but certain projects merit using some consultants.

You might choose to hire an architect even before you've purchased a property. Though that will strike some people as an expensive proposition, keep in mind that residential architects can help you plan and search for the ideal home. Experienced architects, after first helping to clarify the house hunters' goals, can look at a property and provide a sense of what might be required to accomplish the homebuyers' vision. A family that wants to build a new home would do well to have an architect examine the land that's available for purchase and judge how difficult it would be to build on. If renovation of an existing house is being considered, an architect should be consulted to determine the structure's potential, taking into account the clients' aims.

By virtue of their experiences, architects and interior designers become skilled at listening to and interpreting their clients' objectives. A good designer helps people sort through decisions on everything from laundry rooms to living rooms to the relation of the house to the landscape. House hunters share wish lists and images from magazines and books with designers, and talk through ideas with them; through this process, the professional is able to determine which of the homebuyers' goals are reasonable, given the budget. This procedure can be very useful, since house hunters often think some wishes are extravagant when in fact they are quite affordable, and vice versa. Architects and interior designers work on every type and size of residence, from studio apartments to country estates.

Having everyone write separate wish lists is an example of giving each person a format for being heard. Listening to what a family member says to someone else can also help the process.

One of the chief assets of architects is their understanding of the whole picture—cost, time, and value—of any construction needed to create the dream home. They also know the language and tools of residential construction, which helps assure clear communication between the homeowners and builders and others specialists. The architect or interior designer can act as the owners' representative, communicating with real estate brokers, builders, and other consultants. Either of these professionals can guide the homeowners on issues that may lead to misunderstanding or mistakes if the homeowners are unfamiliar with construction terms and techniques and are trying to make all the decisions themselves. Landscape designers are also beneficial because they understand the potential of outdoor spaces—including sites that include questionable marshy areas or rocky hillsides—to accomplish dreams. Small parcels, or properties that seem to have little "usable" land, can be a great buy when a designer detects an affordable way to make them live as if they were larger.

Even if you are not certain the deal will go through, it may be worth the investment to hire consultants, when a property seems to have potential. A client of mine looked at a prewar apartment in New York that satisfied all the needs of his wife and children, but that had a drawback: it lacked the audio/visual and security amenities he was looking for. He found it worthwhile to hire an audio/visual consultant to get ideas about the cost of making the apartment perfect for him as well. This is not necessarily terribly expensive, because many audio/visual consultants are associated with retail businesses; the advice is provided for a nominal fee, in the hope that you will make a future purchase. Many landscape designers, kitchen designers, and even decorators are also associated with retail businesses. As for other consultants, it's worth noting that house inspectors can serve a more creative role than usual if they are aware of what you are looking for in a home. If your aim is to own a historic house, for example, an inspection can reveal the authenticity of its stated date of construction; for example, if a home is represented as being from the early 1800s, a majority of its house parts should date from that period. I have also found it informative to hire a builder as a consultant to look at a potential purchase. When a house could use improvement, a builder can give a sense of the difficulty and cost it would entail.

One of the chief assets of architects is their understanding of the whole picture— cost, time, and value— of any construction needed to create the dream home.

The Real Estate Team

When dream home thinking is far enough along for you to start looking at properties, it's important to make full use—including creative use—of real estate brokers and agents. Real estate professionals should not be seen as being interested only in selling properties and not in helping people achieve their dreams. Of all the professionals, an experienced residential real estate broker will have examined the widest variety of houses in a given area. So asking a broker to share his or her experiences and advice may open up a rich resource of information; it may also suggest ideas that no one else has proposed. Sharing all your dreams and concerns will allow the broker to do the best work possible. The broker's job is to link the right buyer with the right property; an experienced real estate professional may have a great ability to interpret your dreams and find what you're looking for. When working with a broker, be sure also to identify things that you consider negative attributes in potential properties, and listen to the broker's response. A good broker should be allowed to show you as many properties as there are in your price range that have potential, in the broker's opinion. (This also includes properties below what you can afford, as discussed in Steps 1 and 2.) Such extensive touring may introduce you to properties that at first seem not quite right but that possess positive traits you had previously overlooked.

Listening to brokers or agents explain why they are attracted to certain properties can at times open the homeowners' eyes to new perspectives on the ideal home. Brokers may bring designs and details to your attention, especially if they believe you will be responsive to their suggestions. Respond to the properties a broker shows you with as much forthrightness and specificity as possible, remembering that this can be as creative a process for the broker as it is for the house hunter. Working with the broker or agent to understand why certain properties have more appeal than others gives everyone more clues that can be used to discover the home with the greatest potential. Although a broker or agent is not expected to have a design vision, an experienced one can spot a good buy that presents real potential.

The broker's job is to link the right buyer with the right property; an experienced real estate professional may have a great ability to interpret your dreams and find what you're looking for.

PLANNING LONG-TERM

Today few people buy a house with the intention of staying put for life. But quite often they will remain in their new home longer than they imagined. For this reason, it is important to plan long-term even if you are not certain how long you'll occupy a house.

Why do people fail to look as far into the future as they can? Sometimes it's because they fear jinxing an event they're nervous about—the purchase of a property. Sometimes they fear they won't be able to live up to their own expectations. Sometimes they're just overwhelmed. Whatever the reason, house hunters ought to make every effort to think long-term, because doing so will help them avoid serious financial missteps and will help them find a property capable of satisfying them for years and years.

Failing to explore the long term means running the risk of buying a property that will impose built-in frustrations on your future. A client of mine purchased a house that backed onto a bay. She assumed that eventually she could persuade her husband to put a pool in the backyard. But she didn't express that thought to her husband or to her broker. Only well after the transaction did she discover that the town had an ordinance prohibiting swimming pools from being installed in front yards—and all lands adjoining the bay were classified as front yards. Her broker could have alerted her if the woman and her husband had discussed their long-term goals. As that experience shows, it's necessary not only to discuss your long-term goals but also to test them—investigating whether they can be carried out. Doing this at the outset can eliminate some very unpleasant surprises. Each property has its own limitations, and often the only way to know about them is by asking whether the things you might like to do are physically, financially, and legally possible. So make your broker and any other advisers aware of possible future plans. That will empower them to evaluate the properties' potential to live up to your dreams.

Often people spend money on small modifications or renovations soon after the purchase. Later they discover that their improvements must be undone because they conflict

with some bigger objective. For example, a family may remodel a kitchen or add a landscape feature, and then find that this work has to be ripped out when they add onto the house. If you plan long-term, every penny that's spent can add value to the property rather than being wasted.

As a general rule, the best home will be one that is flexible, accommodating change easily. Too often, people waste resources buying a house that's larger than they need. They do this, too, in part, because they didn't approach the decision as a long-term undertaking. Most homes can be enlarged in some fashion. Financially, you may be better off buying only as much house as you need at the outset and expanding it if and when your requirements grow. Therefore, a property that's adaptable for growth is usually a smart investment.

When considering a house on a large piece of land, it is worth exploring the full potential of the land, including whether it could be subdivided for resale. Even condominiums and co-ops can sometimes be expanded or divided. Depending on the size of the investment, you might hire an architect to examine those options.

Only extreme conditions, such as a sudden move or an unexpected change in the household, should necessitate a hurried and haphazard approach to finding a place to live. Even then, it is best to find a temporary solution, such as renting, so as to give yourself the time to make the best purchase possible.

For the majority of Americans, their home is their single largest investment. When a house is well maintained and intelligently improved over the years, the return can be substantial. Take the time to fully investigate your current idea of the dream and what that notion may be in the future. This will pay big dividends. It will lead you to a house you won't be in a rush to sell (reducing your profit or causing a loss). It will lead you to a house you'll be motivated to care for and improve. And it will lead you to a home that delivers the kind of satisfaction we all yearn for. This is an important transaction for everyone involved. Approach it with an open heart, with an inquisitive mind, and with the patience and thoroughness that such a quest calls for, and you stand a good chance of finding the home of your dreams.

Failing to explore the long term means running the risk of buying a property that will impose built-in frustrations on your future.

20 STEPS TO THE DREAM HOME

"Dreams do come true."

A positive attitude and hard work are essential to making the dream home a reality. The ideal place to live is not simply waiting to be purchased; it is waiting to be created. Good house hunting therefore is a creative process, a step-by-step progression from defining a vision to finding the property that has the greatest potential for fulfilling that vision. The time and effort required can lead to gratifying accomplishment: the pleasure of living in a place superbly suited to daily life—and to the spirit. For some, this may mean a smaller, more efficient home that makes life easier to manage, freeing up time and resources to pursue truly important aspirations. For others, it may mean a spacious, better-organized home, providing room for activities that would otherwise go unaccomplished. Gaining one's dream home offers not only practical benefits but also emotional rewards. A house flooded with sunlight or a house with a strong connection to the outdoors can raise the spirits and even improve one's health. Owning a dream home, whether it looks like a castle or feels like a tiny hideaway, is often the best opportunity a person will ever have for achieving romantic notions of the good life. The only limit is one's imagination.

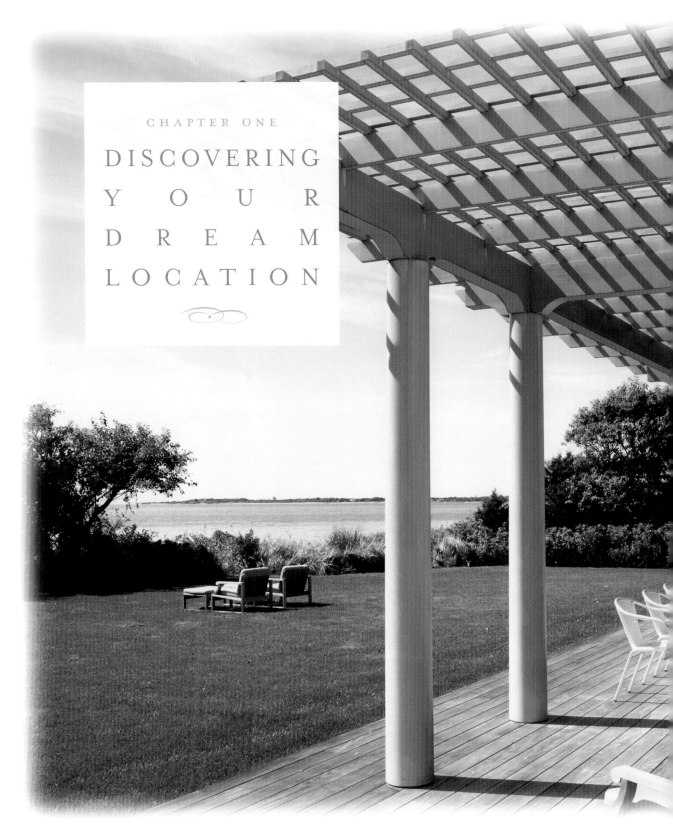

CHAPTER ONE

DISCOVERING YOUR DREAM LOCATION

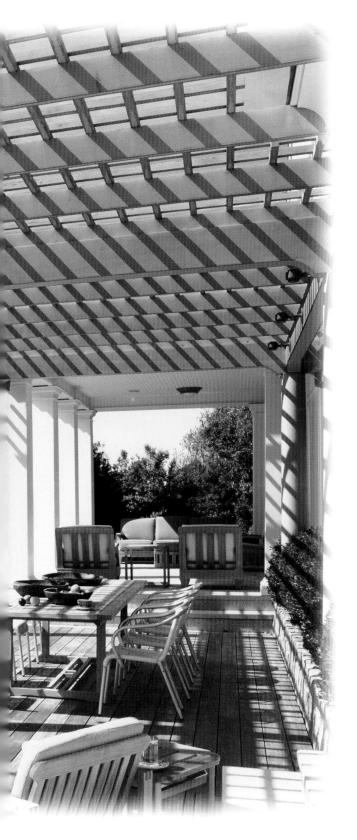

The journey to the dream home begins with identifying the location that has the greatest potential, whether for serving "as is" or with minor changes or with some serious work. Occasionally, the ideal home is out there waiting to be found and simply moved into, but most often the ideal home has to be created. What the homebuyer must do is identify the property that possesses the best attributes for achieving that goal. Being methodical about this endeavor will not only increase the chance of success; it will also make the search far less overwhelming. A step-by-step approach enables people to consider one aspect of house- or property-hunting at a time, and helps them make well-considered choices along the way. These first steps will be enjoyable, but they take fortitude and effort, since there's much to be considered that requires patience and research. The reward for the time invested is finding a place that may be perfect for years to come or even for the rest of your life.

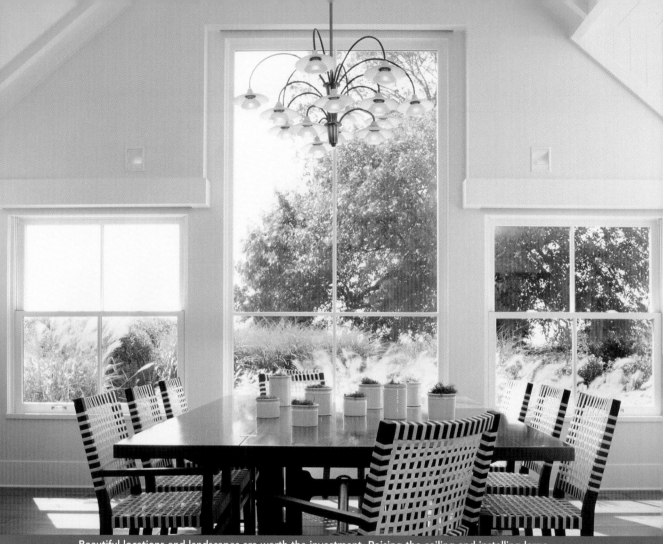

Beautiful locations and landscapes are worth the investment. Raising the ceiling and installing large windows enabled the home to take advantage of the land.

Great Potential

👣👣 When Fred and Nancy found a home on the water that would be perfect for their family, they bought it immediately. The location was great: beautiful view, pretty land, and privacy. The house was not: an ordinary ranch-style home with haphazard additions that did not live up to the exceptional quality of the

site. Finding a home that was fancy or well appointed was not their priority, and they were in no hurry to create one. Their emphasis was on what I consider the ideal goal of good house hunting: finding a property with the most potential to create the dream home. Both of them agreed that this property was it.

For many years the family enjoyed that weekend home with

How much does a dream house cost? When clients first come to our office, I never ask how much money they can spend to buy, build, or renovate a home. That question goes unasked because money should never inhibit the process of imagining what would make a person as happy as possible at home. Besides, I have never met anyone whose notion of the ideal place to live depended entirely on expensive material things or whose goal was impossible to achieve. Rooms filled with natural light, airy and open spaces, framed views, and cozy corners—elements that figure prominently in many people's dream homes—are affordable in any price range.

When it does come down to "how much?" the only simple answer is that price depends mostly on size. Therefore it is best to search for only as much house as is really needed.

Step 1

Setting the Price Range

Establish a price range for the property that leaves enough money to realize your personal vision of the dream home; buy less of a home and do more with it.

Homebuyers need to have enough money to assure that their aspirations, including their desired level of quality, can be achieved. The most common and foolish mistake is to hope for more space than can be afforded. Dreams are made of quality, not quantity.

The price ultimately will be the sum of two different kinds of expenditures. The first is the cost of acquiring the property. This means buying vacant land that you'll develop, or buying a property that consists of land and an existing residence (whether it's a detached house, an attached dwelling, or a condo or co-op unit). The second expenditure is the cost you will incur in developing the land, or developing the land and dwelling, into a dream home. In other words, the second expenditure consists of the cost of improving and personalizing whatever you purchase.

just a few improvements. When the time came to upgrade, they wanted to do so in a way that would maintain the home's unpretentious and comfortable nature. They appreciated quality, not splash. Fred and Nancy renovated the home from top to bottom with fine craftsmanship and materials that should last for generations, but without making the house a showy expression of affluence or style.

Often it is said that homes constructed today are not as well built as those from centuries ago, and sadly, that is the case. It is not that builders, architects, and interior designers lack the skills to help owners create homes as good as, or better than, the homes of the past. It is a matter of money. Though homes today may be provided with better windows, insulation, and mechanical systems, rarely is enough money invested in good details and craftsmanship. One way to deal with the situation is to follow the lead of house hunters like Fred and Nancy: Set a price range well below what you can afford. That strategy allows homeowners to develop a home suited to their needs and aspirations, with resources ample enough that it can become a place of high quality.

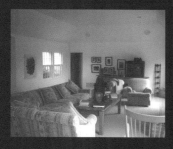

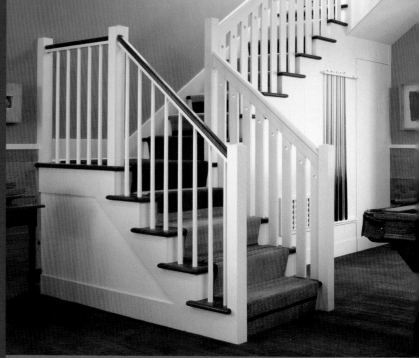

A family room takes on a playful character by adding a fanciful stairway and rough-sawn wainscoting.

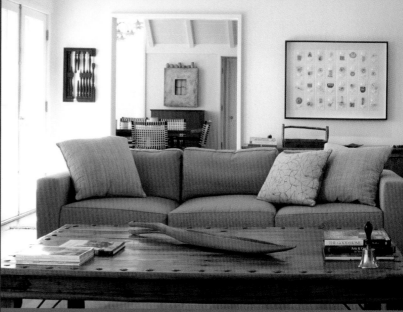

The chopped-up interior of a ranch house was opened to create a continuous space flooded with sunlight and views of the water.

Upfront Costs, Ongoing Costs, and Refinement Costs

The dream location is the property that possesses the most potential within a predetermined price range. To identify the price range in which you'll be operating, consider all the upfront costs, ongoing costs, and prospective costs involved in reaching the vision. People often neglect to determine what can be afforded in light of all the initial transaction costs, such as downpayment, fees, and taxes, and the continuing ownership costs, such as utilities and maintenance. As a result they purchase a dwelling that is more than they can afford out of the gate, and they leave themselves too little money to personalize it over the years—to make it into their dream home. The best advice I can give clients is to investigate both the potential upfront costs and the ongoing costs for the area they are considering locating to; then they can set a price range that brings the whole package within financial reach. There is no need for the costs to be a surprise. Any bank, mortgage broker, or real estate agent would be more than happy to help a customer determine what costs might be incurred with the purchase of a property. The budget work sheet on the following page and the Department of Housing and Urban Development Web site (www.hud.com) provide guides for estimating costs such as maintenance and utilities.

To set a price range, tally all the upfront costs, add up the ongoing costs, and identify how much money will be needed for improvements and personalization. If you're looking at existing houses, the best results will come about if the house that you settle on is priced lower than what you could afford. Do not assume that a less expensive house lacks the potential to accomplish your dreams. A location that costs less leaves more money with which to make it a better place to live. Any property will require some work and resources before it will be ideal—unless it is fully decorated and is landscaped exactly as you want it, a situation that is nearly impossible to find. Even a brand-new home will need to be tweaked to become the dream home. Think of what is involved in buying a fancy new outfit; a few alterations are almost always needed, no matter how well designed or beautiful the garment may be. A rule of thumb is that, at a minimum, ten percent of the cost of a new home should be earmarked for refinements such as painting, light construction, and straightforward landscape improvements. That much is needed to make even a really great house or apartment into one that suits the particulars of its owners.

When considering a property, it is important to recognize that you'll face both an acquisition cost and an improvement/personalization cost. Do not underestimate what it will take to personalize the property. Ninety-nine times out of one hundred, if you choose to work with an existing house, you will have to spend money to make changes or improvements to make it feel like the home you have in mind.

◆ BUDGET ◆
KEEP TRACK OF YOUR COSTS

People don't think of turning to government agencies for help with their personal finances, but when it comes to home-buying, a great information resource is the U.S. Department of Housing and Urban Development, through the literature the agency distributes and through the website it operates (www.hud.com).

Keeping track of all the costs, so that you are in a position to comfortably maintain and improve your investment, is an important aspect of good house hunting. Here is a list that I used when purchasing my own home. Each person should research and create a list that best reflects his or her own financial circumstances.

UPFRONT COSTS

Principal

- What is the true cost of the home?
- Are there things that you believe must be done immediately as part of the negotiation?
- Do you have an accurate estimate of their cost?

Taxes

- Find out all the taxes you will be responsible for paying when you purchase the house.
- Discover which taxes will be required, including transfer taxes and mortgage recording taxes.

Fees

- Find out all the fees from bank and lending institutions that are associated with the purchase and loans for the home, including title search fees, lending fees (points and other charges), and bank attorney fees.

Professional Fees

- Find out the potential cost of all the professionals who may be assisting you with the purchase, including the attorney (who helps you review the deed, draw up the contract, and handle the closing); the real estate broker if a broker represents you as a purchaser; the house inspector; and the architect or interior designer who assesses the property's potential.

Insurance

- Find out the potential cost of all the required and desired insurance coverage you will need, including: homeowner's insurance, umbrella policy; flood and hurricane insurance; and mortgage insurance.

CONTINUING COSTS

Taxes

- Identify all the yearly tax bills that your home will be subject to and find out what tax credits, if any, you may be entitled to. Find out how those taxes will reduce your personal income tax.

Fuel Costs

- From former owners or from the local fuel supply company, find out what monthly fuel costs you should expect.

Utility Costs

- Identify all other utility costs you will incur, such as monthly water bills.

Community or Association Charges

- Find out the monthly costs or charges your home is subject to if it is part of a larger real estate entity, such as a co-operative or condominium building; a retirement or golf-course community; a gated community; a block association; or a townhouse complex.

Annual Maintenance/Improvement Budget

- Set an annual maintenance budget you're comfortable with—from a minimum of one percent of the purchase price to cover routine housekeeping needs, to two or three percent for solid maintenance and continuing improvements that permit house parts to be upgraded whenever they are in need of repair.

Landscape Budget

- Land owners need to estimate the cost of maintaining their property, including tree pruning; upkeep of grass, shrubs, and other plants; storm damage; snow removal; and sidewalk repair.

WISH LIST AND IMPROVEMENT COSTS

Decorative Improvements

- Set a minimum budget of ten percent of the purchase price to personalize and freshen the home prior to moving in. Things that can be included in this budget are furniture, floor and wall coverings, new paint, and new light fixtures.

Upgrades and Space Planning Improvements

- Consider budgeting an additional ten percent for upgrades of finishes, such as replacing wall-to-wall carpeting with hard-wood floors and improving plumbing and bath fixtures or kitchen cabinetry. Consider making minor changes to improve the interior layout, such as combining two small rooms to make a more useful, larger space and adding windows to take advantage of the views or to bring in more natural light.

Major Renovations

- When considering a substantial renovation, find out what the cost is per square foot for new construction and use that figure in determining your budget. For a conservative estimate, simply multiply that cost by every area that the renovation would affect. For example, if you are considering adding on to a part of the house adjacent to the kitchen and a bedroom, include the square footage of the new addition plus the square footage of the entire kitchen and bedroom.

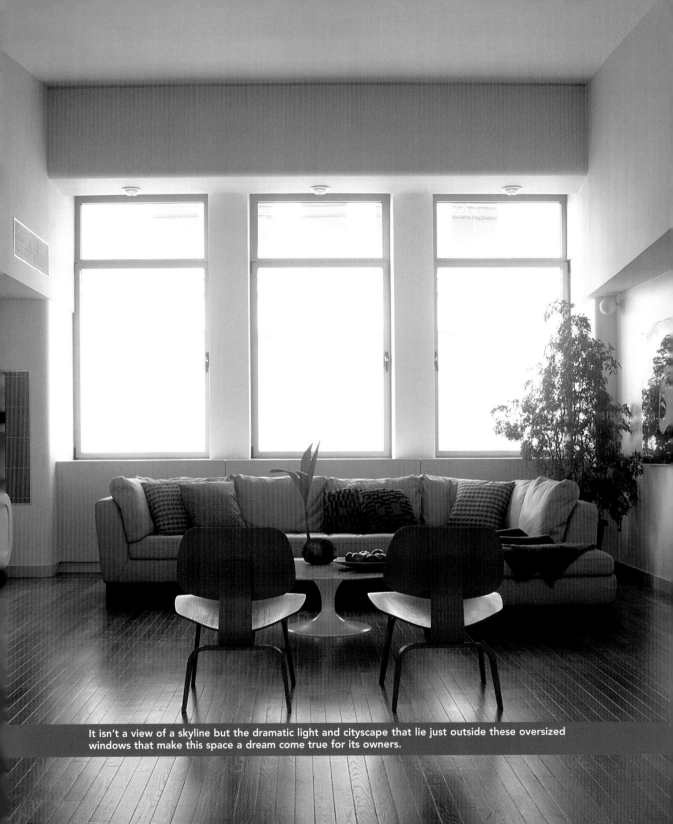

It isn't a view of a skyline but the dramatic light and cityscape that lie just outside these oversized windows that make this space a dream come true for its owners.

Once a price range is established, the next step is to discover the kind of property that will be the most fertile ground for your dream home. This stage is a lot like solving a mystery novel; every possibility must be considered, even those that might seem highly unlikely. Many features need to be considered in a potential property. The ones you should pay the most attention to are those that satisfy your heartfelt desires in a home. Make a list of what is really important to you, and judge all the properties against that list. When a potential property presents features that are attractive but not on the list, don't be distracted; stay focused on the goals that you identified as critical. An apartment with a great skyline view would be nice, and it could be essential to someone who has this on the wish list, but it is also likely to be an attribute that

Step 2

Starting the Search

With wish list in hand or head, consider every location (in your price range), including your current one; keep an open mind.

drives up the cost. If it was not a priority to begin with, it will not be worth the money. Your resources need to be saved for properties that have the best chance of accomplishing all the priorities you laid out for your dream home.

If you yearn for a home within walking distance of an ocean, that's a desire that you can easily identify and put on the list. Other wishes may be less clear-cut, such as the desire for a property that you can readily make into a home that is cozy and well organized. Nonetheless, if you keep those goals in mind, you'll be able to sort through the confusion of seeing many different properties. When you come across a home that "feels cozy" and comes with "lots of storage space," it will be easy to recognize it as a good candidate for your dream home, even if it has other characteristics that do not appeal to you at first. A house that feels cozy and offers plenty

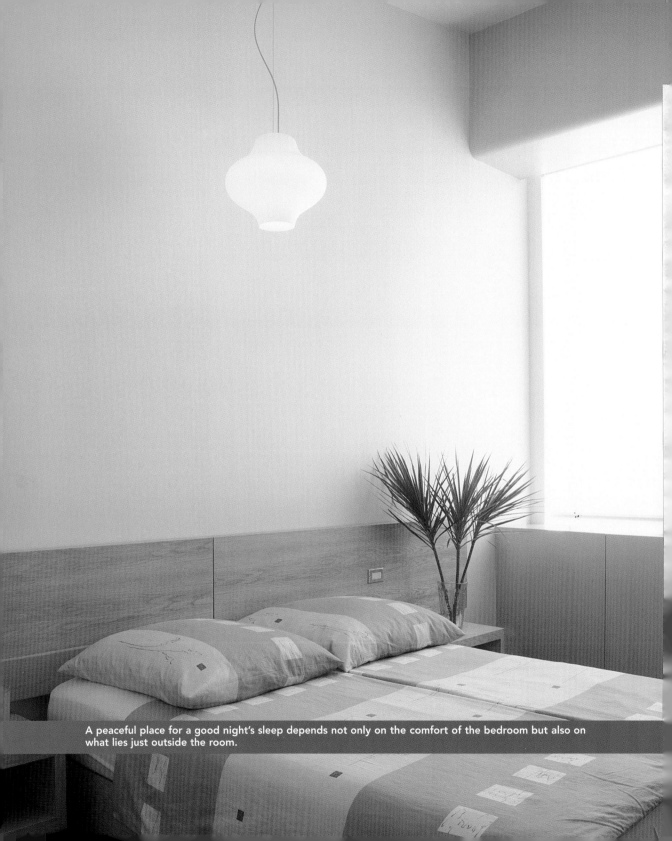

A peaceful place for a good night's sleep depends not only on the comfort of the bedroom but also on what lies just outside the room.

of storage might lack other things on the wish list, such as hardwood floors, but the flooring might be added at a price you can afford, whereas charm and space might be impossible to add without breaking your budget.

When a house hunter has a clear concept of the dream home, a consistent focus on that vision, and money set aside to make the needed refinements or improvements, it is possible to consider many potential locations within the chosen price range. The more you can choose from, the better. But it's essential to stay disciplined—ruling out properties that cannot accomplish your most important wishes, no matter how striking those properties may be.

Make No Assumptions

One of the most important rules for house hunting is the hardest to follow: Make no assumptions about which properties to look at and which ones to ignore. A retired couple I once worked with assumed that no existing house could satisfy their wish lists because they had never seen one that was even close. Their dream was to build a brand-new home, and they resisted looking at any existing houses. At the last moment, their real estate agent persuaded them to look at a particular house, and as it turned out, it was nearly perfect, requiring only a slight, strategic modification to suit their dreams. Had they not looked at existing houses as well as open land, we may never have found the ideal location.

The same is true of any house-hunting assumption. When people are looking for a spot that offers total seclusion, they may take it for granted that land with neighbors nearby would fall short of the goal. But in fact, a small parcel of land surrounded on all sides by dense vegetation can feel far more secluded than a much larger parcel that is exposed on its edges. Similarly, the desire for a view may cause people to eliminate some properties without even visiting them. While it's true that a distant view toward an ocean or a mountain range cannot be created, very few affordable properties come with this feature, whereas many properties offer wonderful localized views—of streams, hillsides, or a beautiful mature tree. Those views can be framed to be as endearing as a vista of mountain or shore.

Recently I accompanied a Manhattan couple looking to retire to the foothills of the Berkshires. Back in my office we talked about their desire to build a new home in accordance

The best location for your dream home may be where you are right now. If your current property possesses amenities that correspond to your wish list, such as being close to town or having a large backyard, and you enjoy your current neighborhood, it can be worthwhile to make even substantial changes to the current house. The cost of a complete renovation can be as high as building new, on a cost-per-square-foot basis. And often this will cost more than purchasing another older house of the same size. But if you like being where you are, you avoid the risk of moving to a location that may not be as pleasant to live in. It's hard to put a price on the peace of mind that comes from staying in a well-loved place.

Despite the tendency to equate the best with the biggest, a magnificent little cottage may actually be what fulfills an individual's or a family's yearnings. This does not mean that dream homes must be small to be affordable, but it does mean that what can be afforded must drive the size of the home.

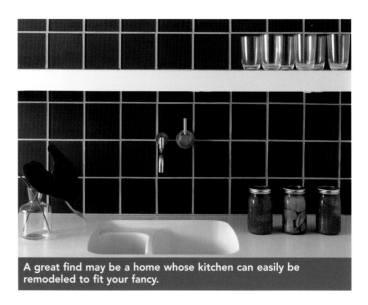

Don't be timid about looking at messy properties or at homes that are not nicely decorated. Almost every house requires at least a new paint job before being moved into. Whereas a house that appears well decorated often has the price of the decoration built into its cost, a house without the pleasant decorating touches may be cheaper. A house that needs only some cosmetic changes to accomplish the dream is the best buy.

When looking for a condominium for my partner and me, we considered places ranging from 1,000 to 2,000 square feet. We opted for the smallest place that had the best light, which was across the street from a park and within an easy commute to our businesses. We didn't get the two bedrooms and two baths we wanted, but by converting a powder room into a full bath and adding French doors on the living room for an occasional guest, we accomplished all our dreams while staying within our price range.

with the wish lists that they had each prepared over the past two months. The goal was a location where they could create their dream of an open, airy home with a long-range view of mountaintops and resting alongside a babbling brook. Their New England real estate agent and I encouraged them to look not only at vacant land where they could build a new home but also at properties with existing homes. Why would an architect not encourage people to build from scratch? Because I knew I could create the open, airy home they dreamed of, either from scratch or through a renovation of an existing one. But I could not create that dreamy view and lovely brook.

Make sure you don't limit your search to houses of a particular size range or to houses that have a specific style or appearance. With so many ways of improving or transforming a house's interior and exterior, opportunities will be missed if you automatically reject locations that are slightly smaller or less attractive than your ideal vision. The only parameter that it's wise to establish when house hunting is the price range. When a young couple was looking for a new apartment for themselves and for a child on the way, they gave themselves a price range that would allow them to look at potential apartments in a variety of sizes and layouts. If they had assumed they should only look at two-bedroom apartments, they would have missed out on a great one-bedroom apartment in a dream location that was easily convertible to two bedrooms.

A great find may be a home whose kitchen can easily be remodeled to fit your fancy.

A house's appearance is hard to ignore when shopping for a good location, but it's best to see as many options within the chosen price range as possible. A particular house may not look good from the curb, but it may have a wonderful interior—open, spacious, and well built. Ruling out such a home might cause you to miss a very good buy, one that may offer many other positive attributes. Even more deceiving are interiors that are poorly decorated; a sunny house whose interior is painted in dark colors may not appear sunny at all, for example. So the best thing to do is to stick to the wish list. A house may have all the other attributes that are essential, despite an initially off-putting curbside appearance or an unappealing décor.

Stepping Down a Few Notches

It never hurts to look at properties that are well below the price range you've established. Doing so may reveal possibilities. Real estate values are often driven by location, size, and physical amenities, such as fireplaces, updated kitchens, and landscape features. A particular property may be lacking in some of those categories, and as a result it may be far below your preset price range. But it may turn out to be a good candidate. With what you save on the purchase price, you may be able to carry out a substantial renovation or addition. The thought of undertaking a major construction project is hard for many people to swallow, but the best house hunting always includes it as a possibility, for two reasons. First, older homes inevitably require some reconstruction or modification over the course of time; this includes improvements that the homeowners did not anticipate initially. Second, construction or substantial renovation, when well planned and carefully budgeted, can be a great one-time investment that leaves little work to be done for many years.

If at the top of your wish list is a desire to live in a certain neighborhood, then properties of all prices, up to the limit you've established, should be seriously considered. Quite often houses are undervalued because of one or two deficiencies, such as having no master bathroom or having only a one-car garage. A good-sized apartment may be cheap because it lacks closet space. Renovation, addition, or other construction may remedy those deficiencies and produce a very satisfying home.

A particular house may not look good from the curb, but it may have a wonderful interior—open, spacious, and well built. Ruling out such a home might cause you to miss a very good buy, one that may offer many other positive attributes.

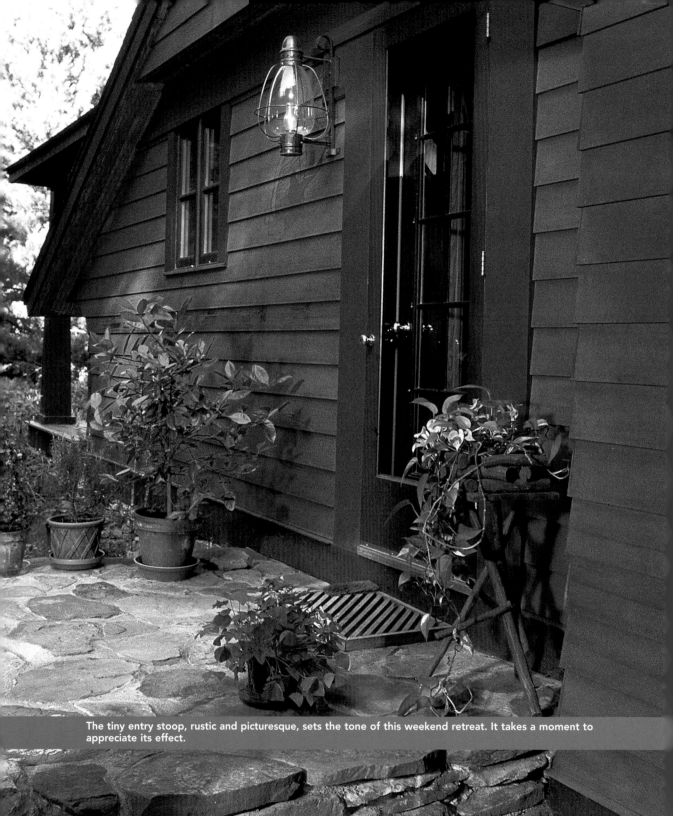

The tiny entry stoop, rustic and picturesque, sets the tone of this weekend retreat. It takes a moment to appreciate its effect.

When house hunting, usually a person can spend only a short time at each property that's being considered. Consequently, determining whether it will in fact be a great place to live—or has the potential to become one—can be quite a challenge. It doesn't take long to see if a house is attractive on the outside, has the right number of rooms, and has special features such a great kitchen or an appealing fireplace. What's difficult is noticing a house's subtler qualities. Is the house in a tranquil area, or is it often noisy? Is it bright and airy during the course of the day, or is it generally dark? Are there little annoyances that make it an awkward place to live? The feel of a location is as important as its appearance, but house hunting is sometimes so exciting and so frightening that it dulls the senses, making it difficult to think clearly.

Step 3

Tuning Your Senses

Check potential locations often, during the full course of the day, week, and even the seasons if possible.

To overcome these obstacles, it is not necessary to demand more time from the real estate agent or to pretend that judging properties is not a daunting task; what is required is to stay focused and make the most of each site visit. You need to learn how to tune your senses, absorb your surroundings, and trust and test your gut feelings about a place.

Sights and Sounds of the Approach

Everyone knows that location affects a home's value. Houses in manicured neighborhoods command more money than comparable homes in less attractive locales. But even within the same neighborhood, one home may be a better place to live than another because of how it's approached. In the eagerness to see properties, a person may not pay enough

When a property seems interesting enough to return to, the buyer should try a different route, to get a feel for what surrounds it.

To heighten your awareness of the approach to a house and of its surroundings, have someone else lead the way. Avoid distracting conversations.

attention to what it's like to get there. A useful clue to what living in a home will feel like is whether it has a good approach. The approach includes such things as the neighbors and the countryside that are passed on the way. Closer in, it may include the driveway, the path to the front door, the front stoop, or, in an apartment building, the lobby, the corridor, and the vestibule. These are all very important features of a home despite often being taken for granted. Happiness at home will be greatly affected by how agreeable the immediate surroundings are. The approach is one of the most critical aspects of those surroundings. For example, a home in a posh beachfront community may prove unpleasant if it is too near a noisy intersection or requires passing unkempt neighbors. On the other hand, I have visited homes in inexpensive locations not known for their aesthetics and found a particular block to be charming because it was beautifully landscaped or because it sat at the end of lovely road. The quality of the final approach to these homes can offset what the surrounding region lacks.

Before entering a prospective new home, you should pay attention to the last few steps that precede going inside. They convey a sense of what it would be like to come to this home each day. No matter how pretty a house is, it will be not measure up if its approach is unpleasant, difficult, or impractical. When house hunting, a person may enter through the front door. But be sure to determine whether this is the route you would use daily. If not, is the everyday entrance pleasant and comfortable to use? Many houses have nice front entries, but the only practical way in is through a garage or down a tight side yard. If much of the home is appealing, yet there is something wrong with the approach, you will have to ascertain whether the flaw can be easily fixed or will be a thorn in the side, continually making life unpleasant. An engaging and convenient approach, such as an easy walk from the car through a pretty yard onto a nice porch and straight into the kitchen, can be such a great asset that it will make an otherwise ordinary house a good value.

Once Inside, Look Outside

The quality of life within a home depends heavily on what lies just outside the windows and doors. Despite a location's virtues and vices, what can be seen and heard from the inside of a home is what counts the most. To test this when I'm

looking at a property for a friend or client, I often ignore the home's interior décor and head straight to the windows. I part the curtains and whenever possible open the windows. No matter how elegant the interior, it will never be an attractive place to live if what surrounds it is unappealing. What lies just outside are good things such as sunlight, breezes, and pleasing sights and sounds—or bad things that make this a poor location. It is always possible to do something to improve a house's appearance, but if the surroundings are harsh, it may be impossible to create a comfortable place for living.

Seeing the outside from the inside is as important as walking around the house, since the attractiveness of the property is not always evident inside the home. A house near a babbling brook may have most of its windows facing the other direction, toward a busy road. The view of the road, and exposure to its noise and fumes, may drown out the benefits of the natural landscape. Important characteristics like these may have been masked by a previous owner's window treatments, but they should not be ignored when house hunting. Conversely, the window treatments may conceal a home's good qualities. I once looked at an inexpensive condominium with a hideous décor and heavily draped windows—and found they hid a view of a delightful courtyard filled with sunlight and flowers. Good house hunting reveals hidden treasures as well as hidden problems.

Test Your Feelings

It feels good to be in a good home. Often you can sense when a home doesn't feel right. The reason certain homes are pleasant to be in is that they smell fresh, the quality of their light is good, and they have a soft sound. When something doesn't feel right about a potential home, you should try to tune into what's disturbing so that you can properly judge it. The problem may be simple; perhaps the house is stuffy because all the windows are shut. However, there may be something unhealthy about its environment. Looking around can diminish your receptiveness to what the house sounds like. It is best to stand still for a minute and just listen. In a home that interests you because it's near the sea or a stream, you should hear sounds of the water. If you want a peaceful place, the house must be quiet to start with. There is no way to create silence. If the house is somewhat noisy,

TUNING INTO THE ELEMENTS

When visiting a location, always find north, south, east, and west so you can understand how the interior will be affected by sun and breezes. The strongest daylight comes from the south. Light from the north, while weaker, is the most even and it can be quite pleasant, without all the heat of direct sun. Morning light comes from the east, and evening light comes from the west. If a sunny breakfast corner is desired and is situated on the house's west side, it will not live up to your hopes.

The prevailing breezes come from different directions in different seasons, depending on the location; these are easy to look up. In most parts of the United States, winds from the north tend to be the coldest, so houses with many windows oriented north will feel their chill.

After determining the sun and wind conditions for each room, you can make adjustments to moderate their effects. Trees, for example, can help reduce the strength of southern sun. If the trees are next to north-facing rooms, however, they can make those rooms dark.

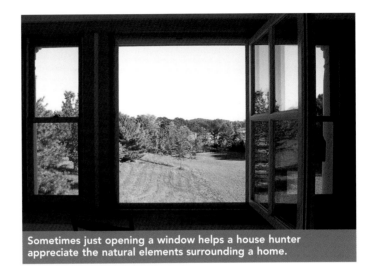

Sometimes just opening a window helps a house hunter appreciate the natural elements surrounding a home.

note that this may be the result of its current condition. An interior without furniture or carpeting, for example, will seem noisy because it lacks those sound-absorbers.

Trust your judgment, but test your perceptions. If a home looks great, offers all the space and amenities you desire, and feels good on the first visit, it is critical to visit it again to test your impressions. The subsequent visits do not need to be with a broker, nor is it essential to go inside. But be sure to visit at a different time of day than your first outing. Find out what the location is like in the morning, in the evening, and at night. Though people rarely think to visit a location at night, this is one of the most critical times to experience it. Potential disturbances are apt to be most noticeable then. Winds may die down at night, making ambient noises more noticeable. Passing cars and their headlights are more intrusive at night, and some urban neighborhoods can change dramatically, from quiet during the day to noisy at night or vice versa. The evening and the nighttime may also offer wonderful experiences, which may go undiscovered if a location is only visited in the daylight hours. Whereas the bright daytime sun may be so harsh and the sky so hazy that even an attractive home doesn't look good, you may find that the house is remarkably peaceful in the mornings, that sunsets fill the house with a wonderful evening glow, and that after dark there are exceptional starry skies or illuminated skyline views.

⚘ HOUSE TOUR STRATEGY ⚘
TAKE THESE THOUGHTS WITH YOU

WHAT TO LOOK FOR

THE APPROACH

Pay attention to what you pass as you drive or walk to the house. Does the area have a specific character such as "a quaint New England village" or "a cluster of lakeside cabins"?

THE PATH TO THE DOOR

What do you see once you step onto the property? Do you know instinctively where to find the front door? How does the house as a whole appear during these first few steps?

THE ENTRY

What is it like when you step inside? Is it gracious, intimate, or dark? What impression does it make on you? Take note of how whatever lies beyond relates to that first impression.

THE ROOMS

Does the room feel comfortable or grand because of its architecture or because of its furnishings? Look for a focal point. Is there something special that is meant to catch your eye, like a fireplace or a high ceiling? Notice the trim. Does it convey a particular style?

THE VIEW, THE SUN, THE SKY

What lies outside each window? How does the sunlight affect the room? How does the interior relate to the exterior? Does the interior have a relationship with the surroundings?

ON THE WAY OUT

Look back and all around the house. It is best to look twice at the outside of the house, because at first you will be disoriented. Try to discover what are meant to be the home's best features. Does it look well built and well maintained?

WHAT TO MAKE OF IT

Ask yourself whether the home fits well with the region or looks out of place. A good home does not need to be a carbon copy of the homes in the area, but it should be a pleasant addition.

The small moment that occurs just before you enter should reveal a home's character: a welcoming place for all to approach or a private hideaway for only the invited few.

Many homes are designed with grand entry halls to make a strong impression, but cozy hallways can be equally alluring. See if the entry makes sense with what follows it.

It's easy to be distracted by the décor and miss the architecture. To recognize a home that has good decoration and good bones, focus on the windows, not the curtains. Notice the woodwork, not the furnishings. A richly detailed home has a certain style to all of its parts.

Never open closet doors, but don't be shy about asking to part curtains. A home should take advantage of what lies outside, and the only way to assess it is to see what's out there.

Subtle beauty and good quality sometimes require a second look to truly appreciate. Don't be afraid to touch the home, because sometimes coming that close helps you see the quality of its construction.

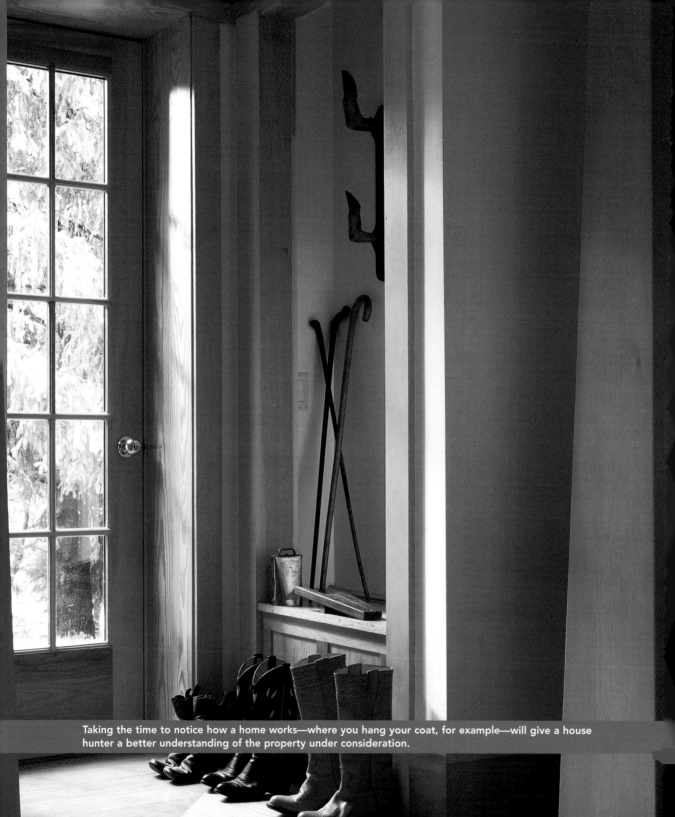

Taking the time to notice how a home works—where you hang your coat, for example—will give a house hunter a better understanding of the property under consideration.

No matter how wonderful a house's style, craftsmanship, interior, and landscape, if the house doesn't have the potential to suit its owners' way of life, it will ultimately be disappointing. The best chance of finding the right home is by visiting as many properties as possible and envisioning living in each of them. The house hunters need to imagine how their possessions and their routines can be accommodated; they need to see themselves in prospective homes—which requires preparation and practice.

Walking into houses for sale can be confusing and disorienting, just like going anywhere for the first time. Houses can also be deceiving. Rooms may look larger or smaller than they really are, depending on how they're furnished. A perfectly good home might seem unpleasant only because of

Step 4

Seeing Yourself There

Practice envisioning yourself—your possessions and your dreams—in places you are considering for locations.

the way it's currently used or outfitted. The goal is to be able to look at a house room by room, overcome the disorientation, and get a sense of how it would look with your own things in place—what it would be like to live there. Fortunately, there are a few tricks of the design and real estate trades that can help.

Understanding the Layout

To evaluate a house, designers and real estate brokers are trained to first try to understand how it's laid out—which rooms are next to which, what their sizes are, how a person gets from one room to another, and where each interior space is situated in relation to the outdoors. Those orientation questions indicate thought processes that a potential

Houses with empty rooms often give a bad impression, looking abandoned or cold. Ignore your first reaction, and imagine how you might furnish the rooms, paint the walls, and perhaps make other changes. Doing this may help you see a property in a positive light.

If you see a home you think you would like to live in but that is beyond your price range, take notes, photos, and measurements of the layout and of the rooms that most appeal to you. It will help you to evaluate other properties.

Don't forget practical things such as where the laundry room is and whether there is a convenient linen closet. Such details exert a big impact on how you live.

It's hard to get a feel for the dimensions of some rooms without furniture, especially large, loft-like rooms such as this.

homebuyer should be using when touring a house. It is best to first walk through a home quickly, paying most of your attention to how it is laid out. This will serve two purposes. First, it will relieve the sense of being disoriented—a stressful feeling like that of being dizzy or lost. Second, it will give you a sense of the overall house, undistracted by the particulars. One nice thing about looking at newly built houses or apartments is that the seller or real estate agent often has floor plans, which are like maps of the homes. I like to take the floor plan with me on the tour. Not everyone can understand floor plans, but the purpose of the diagram is to accurately answer such questions as: Where is the powder room relative to the entry or the back door? How large is the kitchen? How far is it from the dining room? Which side of the house contains the master bedroom, and what room lies on the other side of the bedroom's walls? With or without a floor plan, a person should first focus on these sorts of questions to get a sound idea of how comfortable and practical the layout is.

Once you become somewhat familiar with the layout, it's possible to begin envisioning living in the house and to make a more critical assessment of it, based on your likes, dislikes, and lifestyle. Is the master bedroom near enough to the children's rooms? Is it too close? Is the kitchen organized ideally? Is it within easy distance of the car for unloading groceries? Determining distances and relationships among rooms may require a second look because odd angles, hallways, and vestibules can fool the eye into thinking that spaces are closer or farther apart than they really are. Understanding

50

the layout will help in comprehending what it would be like to move through the home during the normal course of the day. Will the front door be the one that is used often, or will people usually come through the back door? With a feel for the layout, a person can begin to imagine the possibilities for using the house differently than its current owners do. The house hunter may see the potential for modifications. Can the TV room be used as an extra bedroom—or is it too far away from the nearest bathroom? Would adding a breezeway/mud room off the kitchen make a big difference? The more analytical that people can be about how a home is laid out and how they would use it, the less likely they are to be distracted by less significant things such as paint colors or window treatments.

Practice and Prepare for a House Tour

Some designers have a knack for standing in a room and getting a good sense of how big it is and how they might furnish it and use it. This skill is rare, yet extremely helpful; it involves being able to understand quickly what a house would be like when filled with the possessions of the potential buyers and how it would accommodate the buyers' habits. A little homework and a tape measure can go a long way toward enabling nondesigners to do this. Understanding the true size and shape of a room by merely looking at it is often impossible. The width and depth of a room will look smaller

To get a good sense of a screened porch, you have to sit on the porch and take everything in.

When considering properties that have outdoor amenities, such as large decks, swimming pools, or hot tubs, give careful thought to whether and how they will be used. These features can be wonderful, but if underused, they can be burdens or even eyesores.

At one time, built-in pools and hot tubs added value to any home, but in certain locations they have actually been proven to detract from a home's value because people realize that they may not be worth the upkeep and associated costs.

A wood deck may also seem appealing but can have a hard time living up to its promise. Decks can be comfortable and attractive when they work well with the climate, the sun, and the landscape, but many a deck is too large, leaving an expansive surface outside the house that is nearly impossible to shade, doesn't blend into the landscape, and is hard to furnish. If a deck or a pool is desired, it is generally a better value to find a house without one and then use a landscape professional to help you add that feature to the property.

MAXIMIZING
THE LANDSCAPE

A good balcony is one that is comfortable and practical. Ask yourself: Can it be shaded if necessary? Can outdoor furniture fit on it? Is it inviting, or will it likely never be used?

The best outdoor features attached to a house are open and screened porches. They are easy to maintain and almost always make the house more attractive. Terraces paved in stone or brick are a great value as a landscape feature. They are durable and require little or no maintenance. They look good with or without patio furniture, so even if they are not apt to used much, they may be a pleasing landscape amenity.

Other landscape features, such as gardens or expansive lawns, may be good values, but only if they suit your lifestyle. If you cannot afford the time or the services of a gardener to maintain them, it's best to stay clear of those properties or else budget the money to replace the expensive landscape feature with an equally attractive low-maintenance garden solution.

than the actual dimensions when the room has a tall ceiling; petite furniture can make a room look larger than it is. The number and spacing of windows and doors can affect the room's perceived size. It isn't necessary to measure every wall of the house. But you should prepare a list of the dimensions of a few items or uses your new home will have to accommodate. For example, if the goal is a home whose master bedroom is large enough to hold a bedroom set you're fond of, then come prepared with the dimensions of the bed, the headboard, and the end tables. I recommend doing this for a few important objects such as a bedroom piece, a dining room piece, and a living room piece. You can bring a tape measure and discover whether, and how, those pieces would fit in the appropriate rooms. This should be done for storage needs as well. For example, someone might want to measure the linear hanging space needed for clothes, the length of kitchen cabinets, or the shelving in the garage.

A good home has its rooms arranged in a manner allowing easy flow from one space to the next, with little waste of space. The more familiar a person is with the design of interior spaces, the better he or she will be at evaluating and envisioning a house's potential. Homebuyers are famous for looking through pages and pages of interiors for ideas, but it can be more helpful to pay attention to rooms in other people's homes—taking note of their dimensions, shapes, furniture arrangements, and pathways so that you can do a mental comparison. Soon it will become evident that the shape of a room, how you move through the room, and how the walls are positioned are more critical to furnishing or using the room than is its overall square footage. Smaller rooms that are easy to furnish, or rooms not crisscrossed by circulation, can be more comfortable and pleasant than larger rooms hobbled by inefficient layouts. For example, a long, narrow bedroom might have a footprint that's quite small, yet it may be perfect for arranging a bed to one side and a separate desk area at the other end. An oversized living room that forces people to cut across it in multiple directions might not offer much space that's usable for a decent seating arrangement. Sometimes a house that seems odd at first because of the way it's decorated or the way it's currently used may prove to be worth further consideration. Seizing such overlooked potential is possible if you can look at a house and imagine it furnished, redecorated, and perhaps structurally modified to suit your own ways.

◻ LAYOUT STUDY ◻

DRAFT A DIAGRAM OF THE HOME'S LAYOUT

On graph paper draw a simple diagram of each floor of the house or apartment, with one inch representing one foot of actual length.

Measure your furniture and draw a diagram to see how it fits. This will give you a sense of the capacity of the room. Check other layouts for comparison. This diagram shows my apartment with larger furniture. Notice that a king-size bed only fits against one wall in the bedroom. Notice that only a small table fits with this size of furniture in the living room.

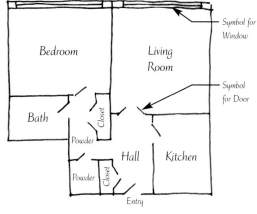

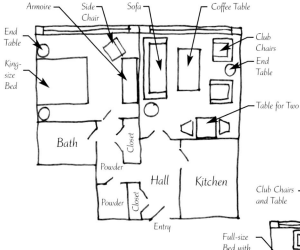

This diagram shows my apartment with the furniture I bought for it. Notice that along with smaller furniture, I got a table for four, a long bench for extra seating, and a bookcase entertainment unit. Larger furniture would not permit these things. Notice with smaller furniture I fit a seating area by the window in the bedroom. Notice I used a full-size bed and it fit on the wall opposite the window and view.

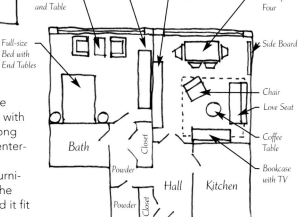

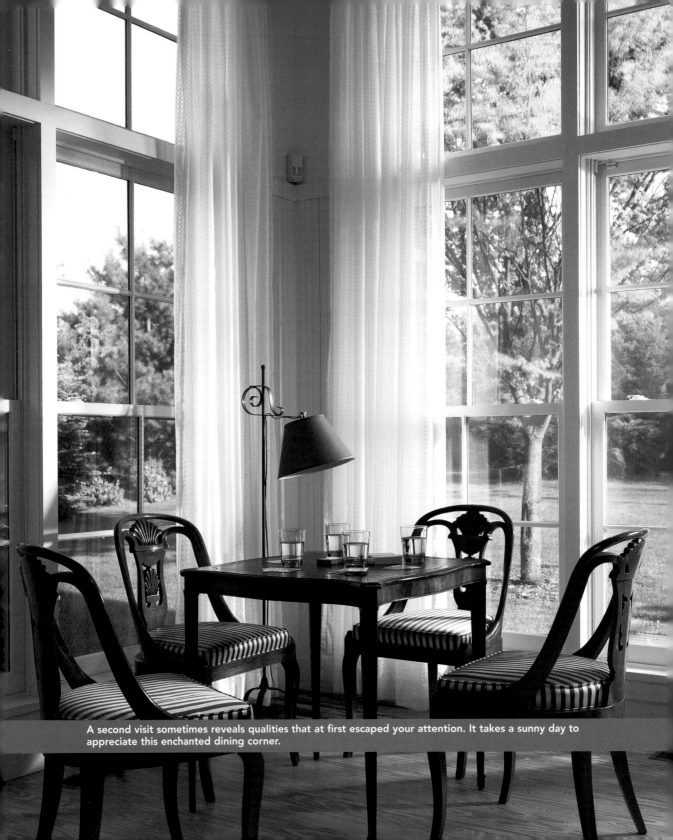

A second visit sometimes reveals qualities that at first escaped your attention. It takes a sunny day to appreciate this enchanted dining corner.

Finding a home that has the potential to fulfill your dreams should not be the end of your hunt. Rather, think of the process as one of narrowing in while keeping your options open. Once people make up their mind on a location, they're in a hurry to move, which is usually not in their long-term interest. I always tell my clients that the easiest way to get the most for their money is to keep an open mind and have patience. An enduring decision requires time, research, and thought.

A home bought too quickly runs the risk of being an impulsive decision that will eventually cause regret. Such a decision usually results from falling in love with certain aspects of a home—its style, its view, its bells and whistles, or other traits—without paying enough attention to quality and practicality. An

Step 5

Narrowing In on Locations

Narrow your favorite locations to two or three and never fixate on one; commit your heart to a location only when it is yours to keep.

eager homebuyer may settle on a house without investigating it thoroughly and without obtaining advice on how good or bad the place really is. Of course it's hard to be enthused without becoming impatient. Therefore it's often necessary to slow yourself down, which is best done by keeping in mind all the work that has to be performed once you find a property that seems appealing. It's essential to keep looking. Remember that if it was meant to be, it will happen; by continuing the search, you'll find that another option will be within reach if the purchase you were contemplating does not come to fruition.

Managing Your Expectations

Whenever I work with clients on house hunting or house building, I try to put their minds at ease through what the

architectural business calls "managing their expectations." This means helping people comprehend what they can expect all along the way. Most people have unrealistic expectations for their dream home. They assume that obtaining a home is like purchasing a new car: Once their needs and preferences have been determined and a choice has been made, they simply pay and take possession (after whatever waiting period runs its course). In the case of a home, that expectation is neither realistic nor wise. From the moment a house appeals to you until the time you finally get it, you have to traverse many steps and hazards, which can be frustrating and exhausting. Acquiring the right property will take more time than you imagined. Plan on it. Even if you find a number of promising possibilities right away, six months to a year or more may go by between the start of house hunting and the day you finally move in. Contract negotiations and paperwork can easily take three months, and that's after an offer is accepted.

Prior to the contract stage, the seller and the buyer have to undertake a long list of preparatory work, such as arranging for a house inspection. Depending on the outcome of the inspection, there may be further examinations, which can result in additional paperwork or renegotiation. Sometimes the seller does not have a clear idea of what the property consists of, so a survey may need to be obtained. A community, condominium, or co-op organization may need to give its approval, and on and on. Every time a hurdle is encountered, you will need to reset the clock on the paperwork, because everything in the contract must be accurate.

Another key to successful house hunting: Be realistic about price. It is a waste of energy and time to play the negotiating game of seeking an unrealistic price or attempting to reduce the price by a sum that's not worth the effort. Do your research, most importantly comparison shopping, so that you understand what the price of the property should be before you get to the point of making an offer. After your offer is presented, the seller may respond with a counteroffer. If the counteroffer is close to what is offered, it's rarely worthwhile for the purchaser to press for a slight reduction in the price. It is usually better to accept the seller's price and thus set in motion all the other preparations, which will ultimately reveal whether the property is indeed a reasonable buy. Remember that all of this will take time; it may disclose facts that will offer the basis for a substantial renegotiation. If the property is misrepresented

※

Remember, never take someone's words as fact. Anything said about a property may turn out to be untrue. More often than not, a property is in some way misrepresented.

※

or if it turns out to have a problem that had not been previously acknowledged, this will require immediate attention.

Remember, never take someone's words as fact. Anything said about a property may turn out to be untrue. More often than not, a property is in some way misrepresented. It isn't that most people are dishonest. There are many reasons, other than outright deception, why the information provided by a seller or a broker may not be entirely accurate. One reason is that quite often things change without the participants being aware of them. The house's condition does not remain as the sellers had expected; something happens in the neighborhood; or rules governing the property become an unexpected obstruction.

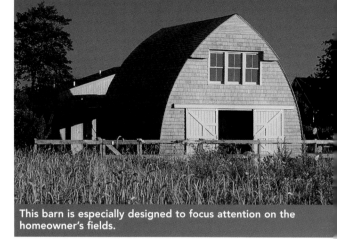

This barn is especially designed to focus attention on the homeowner's fields.

Listen carefully to whatever information you receive, and remember that everything must be verified and documented through careful reviewing. It is better to expect some errors, thereby shielding yourself from disheartenment should some discrepancy eventually emerge.

Keep an Open Mind

Nothing is over until it is over. During all the time that preparations and paperwork are being done, a house hunter should continue to look at other properties. There is really no reason why a seller can not change his or her mind at any point prior to signing a final contract. Even if a contract forces financial damages onto the seller, there is a chance that the deal may fall through. Continuing the hunt is a productive way to use your time, even if the deal goes through. There is much to be learned by continuing to shop for a new home in the area that interests you. For one thing, there is a chance that something better may appear. It may sound disingenuous to pursue a deal with a seller while still considering other properties, but both sides should be honest about the possibility that the deal the two parties contemplated may fail. No one can anticipate what may happen as a consequence of the inspections, financial discussions, and contract negotiations yet to come. A broker or seller may not permit another offer to be presented for the house, but it is a matter of choice as to whether to prevent other potential

A city rooftop is hard to appreciate until you've seen one that's been transformed into usable outdoor space, like this garden.

buyers from seeing the home. A house transaction is the most substantial decision a person may make in a lifetime, so all parties need to be understanding about its magnitude, and to respect one another's need for prudence.

If you're enthusiastic about a house because of its location, you may gain a more comprehensive view of the location's potential and pitfalls by looking at what other people have done with neighboring properties. This may tell you things that have escaped the seller's awareness. For example, if the property you're interested in is heavily wooded and you discover that the neighbor has a larger view, perhaps all the properties in the area, including the one you're pursuing, have a potential view. You can pick up ideas by visiting other properties; then test whether they apply to your prospective home. Looking around may also clue you in to problems in the vicinity. If a house nearby has trouble with insects, flooding, or pollution, the whole area likely is afflicted by that problem. In addition, looking at other homes gives you opportunities to meet more people and come away with a better sense of what it would be like to live in the area. The person you're buying from may have lived in the area a long time; other sellers, with different tenures, may offer a different perspective on the community. All sellers will be encouraging, but information is information, and the more a person has, the better. It can be difficult to ask too many questions of one seller or broker; with additional house hunting, opportunities arise to ask the "one more question" that did not yet get answered. And finally, continuing to look at properties and learn more about a location and the people there may help you think logically about houses and help buttress you against the stress of all the steps yet to come.

Loose Lips...

Ideally, when you've seen a house that interests you, you can simply tell yourself it is a good option and then calmly move forward on all of the work that still needs to be done.

However, the excitement and anxiety may prevent you from being so nonchalant. House hunting may turn out to be a stressful time. People find relief and patience in different ways. For some, it can be helpful to talk about the potential new home, telling others how excited they are and seeking advice from friends and family at each step along the way. I advise clients that they may want to think twice about telling everyone they've found their dream home. Rushing to make a definitive statement to the broker, seller, friends, or even your family can have a down side. Declaring a particular property to be your favorite will step up the pressure on the broker and the seller to encourage you to buy it, glossing over any concerns you may still be harboring. That's human nature. Not only is it in the interest of the seller and the broker to encourage you; most people have an unconscious urge to see you happy, and will not want to say unwelcome things. Even trusted friends and family tend to hold back any less than reassuring thoughts or observations for fear of interfering with your happiness. Another danger is that once you announce the home is perfect, you yourself might become defensive, overlooking flaws and neglecting other properties that may be good options, because your ego is now engaged. It's not usually necessary to put on a poker face or be secretive, but shying away from grand statements can relieve the external pressure in more ways than one. This can help you get the deal done and allow you to keep your mind clear for the further evaluation that will be needed.

Remember, going from finding to finalizing will take time and it may not happen at all. It's hard to exercise patience and stay cool-headed while having a slew of people—no matter who they are—asking frequently about your progress. When it isn't their own house hunting that's taking place, people forget how much time and risk are involved. They may innocently ask about the house situation to make conversation or prove their interest in your well-being, but their questions may come across as a challenge to your skill in negotiations or financing or as doubts about your judgment. When involving trusted friends and family, it is best to prepare them for the emotional support you may need, should it take longer than anticipated or should it prove not to be a wise move. If you find that the people you turn to are only adding to your anxiety, it's best to tell them it may be quite some time before you will have any real news to pass on, and that perhaps there will be nothing to tell them until it is all done.

If an asking price seems way out of line, don't waste time negotiating; simply tell the broker to let you know if the property comes down in price, and move on with the search.

Keep looking even after you find a good property. Any house will need work, even if only to personalize it. Learning from other properties will aid this purpose.

SEEING THE DREAM HOME POTENTIAL

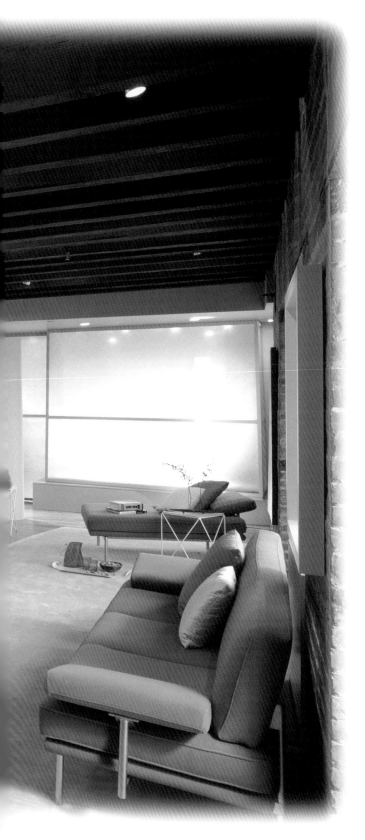

Buying a house requires more money than any other purchase you'll probably ever make. It also demands a large investment of time, emotion, and faith. To be certain it's worth all the resources and effort, the house must be judged not only for what it is now but also for what it will be over the years to come. Casually looking at a condominium, a townhouse, a freestanding dwelling, or a parcel of land will never reveal its full potential. There are many aspects to consider, and it's easy to get swept away by an element or two—a beautiful view, a sunny living room, an attractive façade. What you should aim to do is see the individual features but also focus on the big picture and reflect on the long term. Is the house attractive and well built? Do the interior and exterior reflect sound design principles? Will the property be difficult to resell? Will it be too large after the children have gone? Aesthetics, utility, quality, potential—all of these should weigh in the decision, yet no single piece of information should drive the outcome. A satisfactory and lasting decision calls for understanding both the parts and the whole.

Most likely you will need help. A complete assessment of a home's attributes requires the input of professionals such as architects, house inspectors, and licensed contractors. But the assistance of these experts is a supplement to what matters most: your desire and effort to judge a home for yourself. Good house hunting is like treasure hunting; the most challenging search often leads to the most satisfying result.

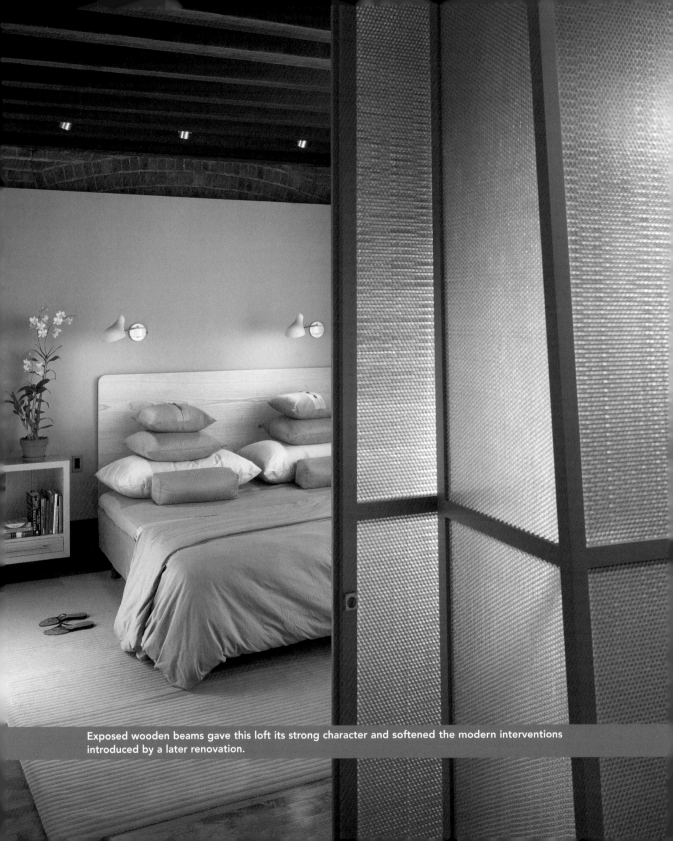

Exposed wooden beams gave this loft its strong character and softened the modern interventions introduced by a later renovation.

A house is worth what someone is willing to pay for it—no more, no less. Good house hunting requires an awareness of what determines the price, what attracts potential purchasers to the house, and what the house is worth personally to those who decide to acquire it. Misconceptions about house prices abound. Let's start by discarding the idea that the price of a house is determined by the cost of its construction. Construction expenditures matter, but they're only one part of the equation. You can spend a certain sum to build and maintain a house in one location and spend exactly the same amount to build and maintain an identical house in a spot a few miles away, yet their prices may differ substantially. One of the chief reasons for the difference is location. Even within a single block, noticeable

Step 6

Assessing What's Out There

Estimate the value of the home through comparables, replacement cost, and its unique features.

variations may arise, in part because a house on one site shows better than a house a short distance away.

Another reason prices differ, even among houses that cost the same to construct, is divergence in their design and character. Special features such as views, landscapes, or design elements (for example, an impressive wraparound porch or a large expanse of glass) can boost the value significantly. In recent decades, as the nation's waterways have been cleaned up, vistas of oceans, lakes, or rivers have become strong selling points. In addition to these determinants, there's a highly subjective factor you shouldn't overlook when figuring out what a property is worth: what appeals to you. If you find something about a house particularly alluring, you may be willing to pay extra for it; offering an above-market price is fine as long as you realize that you may not be able to recoup

the premium or may have to wait quite a while to find another buyer who shares your preferences. In general, the best buy is a home that affordably offers you the features you want the most and that gives you the best chance to achieve all your goals.

Comparable Values

The first step in understanding a house's value involves making comparisons. Here it's important to note that the most comparable house may not be the one that looks the most like the one you're considering buying. Nor is it necessarily the one closest in size. Comparables have to do with a whole slew of characteristics. The best way to get a handle on this is to identify all the houses in the area where you want to live that are for sale at similar prices. Make a list of what each has to offer (regardless of whether each of them interests you). If a house is listed by a real estate broker, odds are that it is not mispriced, unless a broker tells you it is. Rarely does a broker

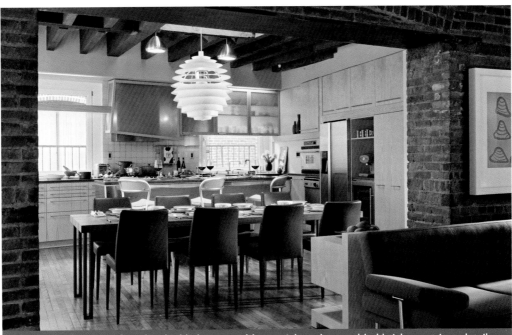

Lofts can be fantastic when they highlight great old materials such as molded bricks, cast iron details, and industrial wood floors.

list a home for an extended period of time at the wrong price—a price the market will not bear—without providing a clue to potential buyers that it's priced high. Conversely, if the house is priced much lower than very similar houses in the same locale and if it has been on the market for some time, this could be a sign that it suffers from real problems, possibly involving the construction, the neighborhood, deed restrictions, or other limitations, that are driving the price down. Often, however, it is perceived differences that make a great impact on price, giving certain houses special appeal. The perceived differences may be matters of style or taste that have little to do with the objective quality of the house or the potential of the property.

In making comparisons, items to note are: the ages of the houses in the same price range; the number and kinds of rooms; the sizes of the properties; special features such as views or mature plantings; other property amenities such as garages, swimming pools, and auxiliary buildings; community amenities such as a common tennis court; and any other features that are significant enough to be cited in an advertisement. Sort the houses being compared into districts, towns, or neighborhoods, since the locale typically influences the price. Compiling and reviewing this information will give you a sense of what's driving the prices of the houses that interest you. If many of the houses in your chosen price range are much larger than the one you're most interested in, an unusual feature or some aspect of its location has probably caused the owner and the broker to set the price high. If the feature is not one that's important to you, the house is probably not worth the extra money. If the house you're interested in is much larger than the comparables, this may indicate that its location, condition, or design is reducing its value; this may or may not be a stumbling block for you. Poor condition is something that can be confirmed or ruled out through house inspections; the problems may be cosmetic flaws that can be overcome at little expense, or they may be permanent or chronic defects that will be almost impossible to remedy. A location may suffer from real, objective problems, such as noisy neighbors, poor schools, or proximity to industrial sites. Or the "defect" may lie mainly in the realm of perception, such as the unstylishness of certain addresses. Design and aesthetics are aspects whose value is most elusive; you should feel free to trust your own judgment on those matters.

EVALUATING ONE-OF-A-KIND HOMES

Unique homes are much harder to price than so-called cookie-cutter houses. A one-of-a-kind house frequently also takes longer to find a buyer who appreciates its unusual features. For the buyer, an unusual house can be a very good value.

Typically a well-designed, well-crafted house that's unique was more costly to build than a conventional one. Oftentimes special labor and materials were involved. Since the quality of the design and construction is so integral to the value of a home, the question to ask is what team was involved in its creation. The best such houses are designed by licensed architects and constructed by contractors with a solid reputation.

Ideally, the house's creators are still in business and can be contacted. Quite often they have a personal interest in the home. When they're excited to talk about it, this usually indicates that the house was put together well and has the potential to be satisfying home for years to come.

WHAT'S OUT THERE

DO A COMPARISON

There are a number of ways to put a value on a home: comparing it to other homes; determining what it would cost to replace it; and setting a price for features that are considered valuable, such as the view, a location next to a creek, or being within a historic neighborhood, can all help the process. A personal assessment is what matters most because the value of a home is subjective; a home can be precious to one buyer, yet not attractive to another. Here, as an example, is my personal assessment work sheet for my apartment shopping in Manhattan.

	LOWER FIFTH APARTMENT	GREENWICH VILLAGE APARTMENT	BATTERY PARK APARTMENT
Size	750 sq. ft.	1000 sq. ft.	850 sq. ft.
Bed/Bath	2/1	1/1	1/1.5
Condition	Good	Average	Brand new
Kitchen	Good	Poor	Great
Location	Very desirable	Desirable	Good, but less desirable
Doorman	Yes	No	Yes
Views	No	Good	Great
Comparable value for neighborhood	Slightly higher than comparables, but an excellent building	Slightly lower than comparables, yet a good building	Much higher, but best building in area
Replacement cost considerations	Fairly new kitchen, all hardwood floors, and decorative moldings would be expensive to replace	Few features are expensive to replace	All finishes and fixtures are premium, very expensive to replace
Features that all buyers would find valuable	Location and second bedroom	Location and spaciousness	View, gym, and interior finishes
Features that are valuable to me	Proximity to restaurants and shopping. Great neighborhood	Architecture of building	Proximity to waterfront and could easily walk to work
Features that devalue the apartment	Lack of light. Small rooms	Current conditions	Neighborhood

Replacement Value

When a house has many of the features you want, it can be a worthwhile exercise to imagine what it would cost to build a similar home with those features—starting from scratch. This is similar to what insurance companies ask homeowners and agents to do to calculate the insured home's replacement value. It can be very helpful when comparing two houses that have different features but that are in the same price range. For example, if two homes both have decent kitchens but one of them also has a wood stove, there's an added value beyond that of the wood stove itself. First, there is the time and effort the homeowner went through to acquire the stove. Second, there is the labor that went into installing the stove; that could be twice the value of the stove. Third, probably modifications were done to the house so that it could accommodate the stove. Fourth, assuming that the stove is in proper working order, there is a value to the extra heating efficiency. Finally, there is the ambience generated by the stove. A small house containing a number of features like this can be worth a lot more to the right buyer than a large house that lacks them.

The replacement value of a well-maintained older residence often exceeds its sale price—sometimes by a large margin—because the high-quality old house was typically built with materials and skills that today would be hard to find or quite expensive. For example, a 1920 house of stone or brick in an old neighborhood might sell for the same price as a new wood-sided house on the outskirts of town. The replacement value of an old stone house will be far more than that of the new wood one. Replacement costs are higher for dwellings that display remarkable craftsmanship than for houses of ordinary construction. On the other hand, new homes (or apartments) built with inexpensive materials, finishes, cabinetry, and appliances may prove to be overpriced when you consider their replacement value.

Keep in mind that when the right home comes along (one with good quality, the character and features you want, and a price you can bear) it can be a good buy even if the home is priced a little high in relation to the comparables. Missing out on a good home because its cost is slightly higher than a similar home can be a mistake, given all the time and effort that goes into the search. In summary, the value of a home arises both from what it commands on the market and how close it comes to the dream.

The real value of a home is determined by its ability to fulfill a person's needs and aspirations. No house will be perfect as is, so evaluate what it will cost to make the home just right. Some houses will require more money than others to be transformed into dream homes.

Never evaluate how a house's value compares with other properties simply by reading real estate listings. If time does not allow for visits to comparable houses, be sure to at least drive by the listed houses to make a more informed assessment.

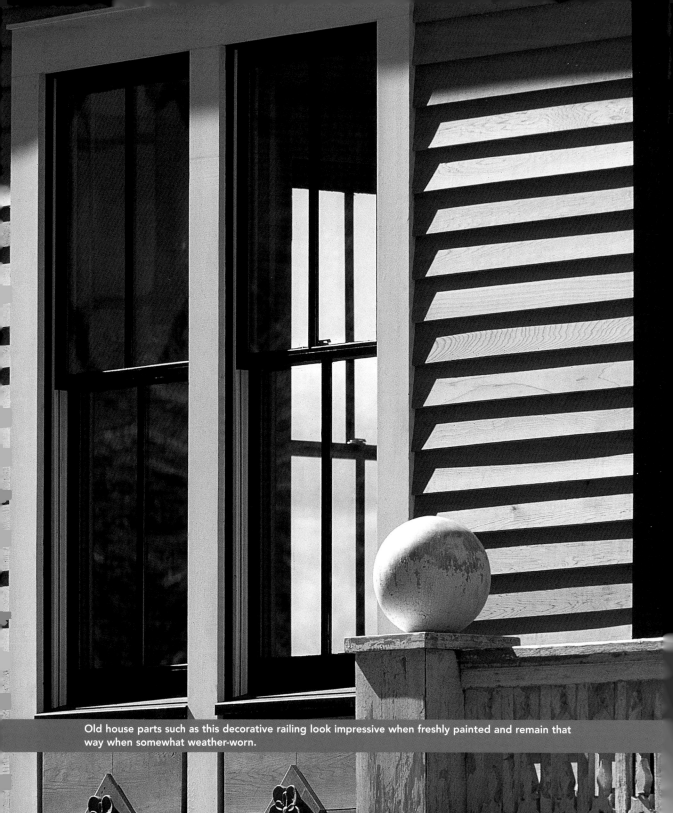

Old house parts such as this decorative railing look impressive when freshly painted and remain that way when somewhat weather-worn.

The real estate industry has an expression to describe a house's attractiveness from a distance: "curb appeal," meaning the degree to which the house looks good from the street. The problem with curb appeal is that the homeowners do not live on the street. They live, for the most part, inside the home. Anyone who places an undue emphasis on exterior appearance is likely to reach a skewed conclusion about the house's desirability.

To a considerable extent, people's reactions to exteriors revolve around style. A house that looks a bit traditional from the curb may turn off people who prefer a more contemporary look. Conversely, a house in a contemporary style may dampen interest among homebuyers with traditional tastes. Obviously, style affects thoughts and emotions, and should not be

Step 7

Judging a Home by Its Cover: The Exterior

Never judge a house by its "curb appeal." Look for pleasing proportions, an appealing setting, and quality construction.

dismissed out of hand. But in my view, house hunters ought to give serious consideration to dwellings of every style, because important features on their "wish list" may be present in homes that would not survive a superficial examination related to exterior appearance. What matters most is whether the house is thoughtfully designed, intelligently sited, and solidly built all the way around. Over time, the house's value and the quality of life it offers will be affected much less by its street presence than by its proportions, siting, and construction.

Pleasing Proportions

To draw useful conclusions about a house's exterior, you have to comprehend why certain things make such a large impact. Think of this as learning to read; you have to understand the

Even if it's a condominium or co-op unit, it is imperative to evaluate the property from the exterior. Condo and co-op buyers are purchasing a share of the entire building and its complete maintenance.

Sometimes the easiest way to judge proportions and compositions is to photograph the house and compare it to an image of another home in a similar style that is highly admired. Are the windows and doors as nicely arranged? Are the shapes as pleasing to the eye?

meaning of each of the words before you can grasp the meaning of the sentence. A house designer has four things to work with in designing the exterior: the overall shape (including the shapes of the roof, dormers, wings, porches, and the like); the windows and doors; the trim that surrounds and outlines the house's windows, doors, and overall contours; and the exterior materials (including wood, brick, stone, metal, asphalt, and stucco). If you first spend a little time on these four elements of the exterior, you'll be on your way toward understanding what makes a house look the way it does.

The exterior shapes, the design of windows and doors, and the trim are the three elements that most influence a house's appearance. Traditional homes, from Colonials to Victorians, tend to be collections of recognizable "house" shapes and details, such as gabled roofs, dormers, turrets, double-hung windows, and porch columns. Contemporary homes tend to feature more unusual shapes and elements, such as low-slung or flat roofs, curved walls, asymmetrical angles, large spans of undivided glass, and covered patios with metal posts. Transitional designs mix the recognizable shapes with more sculptural ones for a look that is both modern and traditional.

Good design, regardless of whether it is traditional, modern, or transitional, rests on good proportions. The shapes and elements employed in the house please the eye because of their thoughtful dimensioning. Height, width, and depth are carefully determined with an aim, usually, toward creating an elegant, natural, and composed appearance. You don't need an artistic eye to sense whether the parts of a house are well proportioned, but familiarizing yourself with examples of good proportions is useful. Houses published in design books and magazines are often discussed in terms of their overall proportions. Some of the words and phrases employed to describe good proportions are the same ones used to characterize the results of a good recipe, such as "delicate" and "balanced," or to compliment a well-designed dress, such as "graceful" and "nice lines." Proportions play an important role in the shapes of individual windows and doors, the contours of porch posts, and the forms of other parts of the house. Tall, narrow windows and doors oftentimes seem attractive because of their elegant, thin proportions, while short and fat porch columns may be striking because of their robust proportions. A skillful house

design has its parts arranged in pleasing compositions, meaning that they are organized nicely, as in any high-quality pattern work. A house that is not in the most popular style but that possesses great proportions and a strong feeling of composition may sometimes take a little longer to appreciate, but over time it may prove more satisfying than a house that employs a more sought-after style but that suffers from poor proportions and compositions.

Materials

A good piece of furniture made of fine materials stands out in a room. The first thing people want to do is touch it. Rarely do people get close enough to touch the outside of their house; perhaps this is one reason why so many people fail to appreciate the character of the exterior materials. Many beautiful materials are available for use on residential exteriors; if you cultivate an awareness of their qualities, they are a joy to own, even without putting your hands on them. Houses with wood

Edge detail and a copper flashing ensure high quality despite the ordinary asphalt roof shingles.

siding and substantial wood trim look far more elegant and expensive than homes with vinyl siding and little or no trim. In some regions, mold, insects, or severe weather make wood less practical, and wood siding typically does cost more to install and maintain. But in most cases the benefits to the appearance are undeniable.

Other good exterior materials include brick, stucco, and stone, or combinations of these. Older houses clad in these materials tend to be valuable because these materials are often expensive to purchase and install. Old-fashioned bricks were molded and baked in small batches, one brick in each mold. As a result, the color tends to vary slightly from brick to brick. The bricks also have soft edges and small surface imperfections. All of these give the old bricks a rich look. New house construction methods lean toward thinner or simulated versions of brick, stucco, and masonry. The

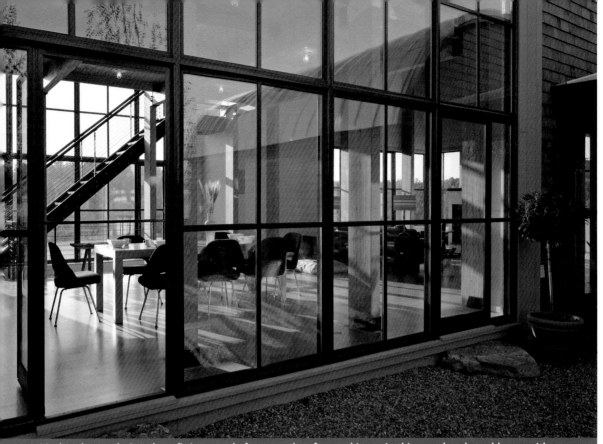

Modern house designs benefit immensely from good craftsmanship, as in this wood and steel home with custom-made windows.

best of the new versions look very much like the originals in color, texture, and joinery. However, not all aspects of the older houses can be re-created with newer methods of construction, and sometimes it's a bad idea to try. The result may look like a poor imitation. Big old houses surfaced in stucco often had solid block walls behind the plaster-like outer coating. Walls of that kind expand or contract hardly at all when the temperature or humidity changes, so they generally perform well and look attractive. New houses of lightweight construction are just as sturdy, but their walls swell and shrink to a greater extent, and in certain climates this can harm the stucco and make it a bad material for the exterior. There are insulating panels that can be used as an exterior surface that give the look of stucco. In certain areas, when properly installed, they can be a high-quality finish; however they may damage easily and require seams that detract from the appearance.

House Inspection: Quality Exterior Construction

The exterior's main job is to resist nature, particularly the weather. The harshest components of weather are water, temperature, and sun. These are the things that cause paint to peel, colors to fade, mold to grow, foundations to sag, and structures to rot. A professional house inspection will report on the dwelling's current condition both inside and out. The inspection may or may not be able to pinpoint the successes or failures of the original engineering of a home that relate to its current condition. Still, the more information a person can gather, the less likely a home will be purchased on a whim, or with a false impression. The best way to follow up on a house inspection report is by paying a homebuilder to read the report and look at the house. This is not to test the accuracy of the report, but rather to give you a sense of the meaning and potential future costs associated with what the inspector found. For example, the report may state that the home needs a new roof. Perhaps this will be as simple as replacing the roofing materials on the surface, which may not be costly. However, a closer reading of the report may reveal that the design of the roof and its construction are less than ideal, allowing rain, ice, or snow to damage the structure. Adjustments might be required during replacement of the roofing material, hiking the cost.

A well-built house allows rainwater to flow quickly away from all surfaces. A house inspection might point to inadequate drainage around the house. This may result in a soggy basement, but in addition, water accumulating around the house may soak into all of the exterior materials, shortening their lifespan and requiring more frequent maintenance. On the other hand, some weather damage, such as fading from the sun, water stains on siding, or rotting of porch post bases, may be superficial. It may indicate nothing more than a need for some freshening. Ironically, a new house clad with weather-resistant materials but poorly constructed can look great but be in far worse condition than a much older home that is well-built but showing normal wear and tear. It is better to invest in a house that was built with solid materials and sound methods of construction, even if they require a bit more exterior maintenance, than to buy a "maintenance-free" house that is cheaply put together. Should things go wrong down the road because of poor construction, the problems may be devastatingly expensive.

It is better to invest in a house that was built with solid materials and sound methods of construction, even if they require a bit more exterior maintenance, than to buy a "maintenance-free" house that is cheaply put together.

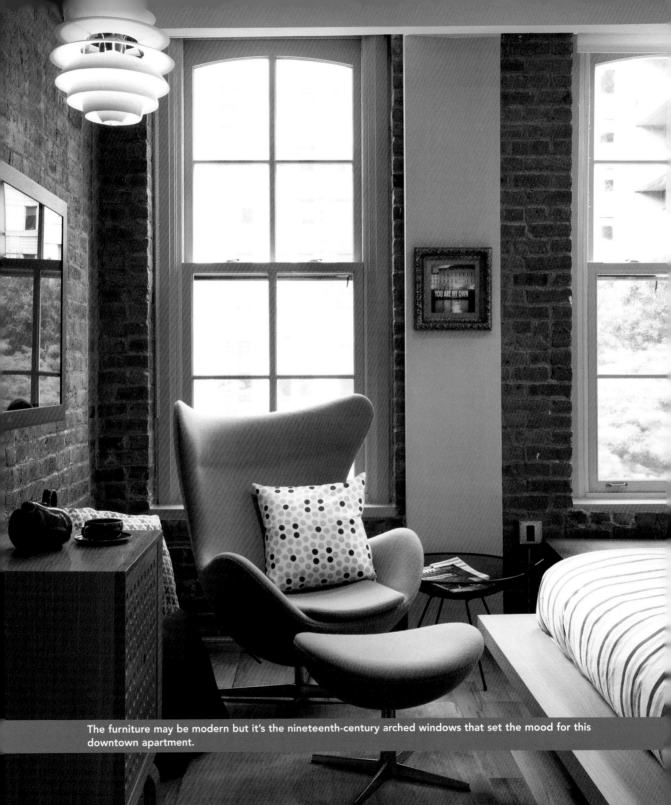

The furniture may be modern but it's the nineteenth-century arched windows that set the mood for this downtown apartment.

Many successful magazines report on the interior design of homes, from *Architectural Digest,* which has a long history of featuring the décors of the well-to-do, to *Better Homes and Gardens,* which was established in the early 1900s to give decorating and gardening tips to farmers' wives. All of the publications emphasize the power of well-chosen decorations and furnishings to transform an interior. All of them also mention the importance of a home with "good bones," meaning an interior that possesses pleasing proportions, good light, and perhaps a sense of style—even before any decoration has been applied. Those qualities are what a person should look for when house hunting. It is far less expensive to make the interior of a house appealing if it has good bones. The house may be easier to maintain and

Step 8

Seeing Beyond the Sofa: The Interior

Recognize that good homes have interiors that look comfortable and attractive, even without a stick of furniture in them.

organize, it may seem more spacious, and it's likely to be more fun to live in. During house hunting, you want to be able to judge the interior by evaluating empty rooms or by looking beyond someone else's furniture and decorations and seeing whether the "good bones" are present.

Finishes and Furniture

Any house for which an offer has been accepted should be inspected by a professional. But before that's done, the potential buyers should make multiple visits and examine the property carefully. The interior ought never be judged by its décor unless most of its finishes are new, on the one hand, or, on the other hand, have been meticulously maintained and many of the furnishings come with the house. Wall

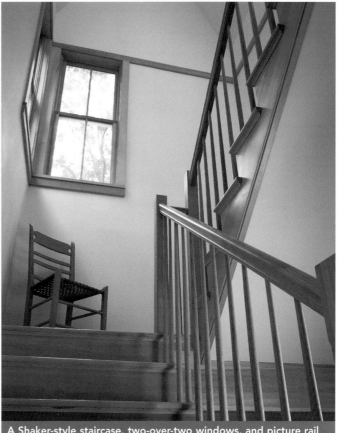

A Shaker-style staircase, two-over-two windows, and picture rail detail set the mood of this small home in the countryside.

finishes and window treatments are designed to create a powerful impression, and it's hard to discern their true quality or condition during a typical tour. Painted walls and wallpaper rarely get refinished more often than every ten to twelve years. The damage that sun and dirt have inflicted on them usually goes undetected until the previous owner's possessions are removed and the room stands empty. Suddenly it may look much more tired than it did when filled with furnishings. Even decorative moldings, which ought to be easier to judge, can be deceiving; despite years of experience, I admit that it's hard for me to gauge their quality or authenticity unless I study them longer and more carefully than a quick house visit allows.

Seeing a house fully furnished can skew your judgment and make you think the house is either better or worse than it really is. If the décor or the furniture is of poor quality, in bad condition, or not to your liking, the whole interior may seem off-putting. Stripped of the owner's furniture, the same space may seem much more enticing. You can overcome the problem of judging a furnished interior by focusing on the dimensional relationship of the furniture to the room—the "scale," as designers call it. Notice how large or small the furniture is. Look at how much space is between the furniture and the walls. Find out whether you feel comfortable maneuvering around the furniture currently in the rooms. Following those procedures will help you gain a better perspective on the house's virtues and flaws.

An empty room that's freshly painted presents a different kind of challenge. On the plus side, such a room lets you attune your senses to fundamentals of the interior: the shapes of the rooms, the source and the strength of sunlight, and even the sounds coming from neighboring homes. However, the fresh paint may cover up flaws such as leaks, cracks, and inferior materials. Moreover, an empty room may appear too small or too large with its lack of furniture; this can make it hard to determine whether the house is the right size for your purposes.

The least risky advice is to assume that all the finishes and features will need to be replaced or removed. This may seem extreme, yet very often a room that's highly decorated requires serious refurbishing if it's to look equally good after the new owner moves in. On the other hand, if the room stands up to the good-bones test, a far less expensive sprucing up may suffice.

Efficient, Organized Spaces

No matter how large a home you can afford, there is nothing to be gained by buying a house that is inefficiently laid out. One important criterion for a well-planned house is how much space can be put to use rather than wasted. Wasted spaces are areas that do not lend themselves to how you'd like to use them or outfit them—a section of a living room that cannot be easily furnished, for example, or a deep closet that cannot accommodate many clothes. A well-used space serves its functions well—for example, a kitchen corner that's perfect for preparing a meal, storing pots, or holding

The least risky advice is to assume that all the finishes and features will need to be replaced or removed. This may seem extreme, yet very often a room that's highly decorated requires serious refurbishing if it's to look equally good after the new owner moves in.

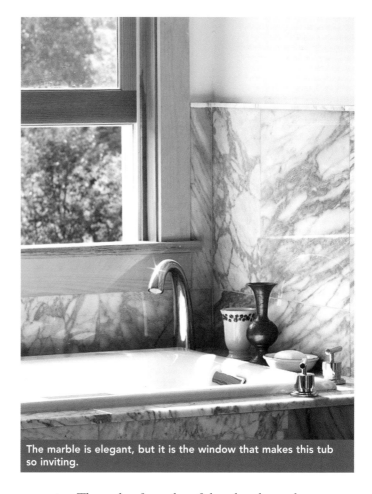

Be skeptical of interiors that are heavily decorated. Look closely at their spaces and surfaces. Decoration may hide serious design and construction flaws.

Architectural and decorative features can be added to improve oddly shaped or ill-proportioned spaces, but accomplishing those fixes may be costly.

The marble is elegant, but it is the window that makes this tub so inviting.

groceries. Through a few rules of thumb, a house hunter can evaluate dimensions, shapes, and layout and get a sense for how usable the spaces of the various rooms are. The standard for seating arrangements is that a sofa and two chairs, facing each other across a coffee table, fit neatly on a nine-by-twelve-foot rug. If the room can accommodate this arrangement, that's a favorable start. If the room lacks enough space to add other seating, such as a bench along a wall or an additional seating group, this may indicate that space is being wasted. When looking at a living area, see if it accommodates one, or multiple, comfortable arrangements of seating, while wasting little or no space. Overly large distances between pieces of furniture make communication uncomfortable.

Many rooms need less space to serve their functions than might be imagined. Dining areas need only be large enough to fit the table and the chairs alongside (not tucked under) the table, plus twelve to eighteen inches for people to pass behind the chairs. A smaller space can be used for dining, such as the corner of a kitchen, if seating is provided on one or two sides by a banquette set flush against the wall. Closets need to measure only twenty inches from the back of the door to the wall; unless they are at least five feet deep and five feet wide, little extra storage can be gained from additional depth. Kitchens need no more and no less than three to four feet between any two working surfaces. Although larger spans provide more room for two cooks, a distance of more than four feet adds unnecessary extra steps for a single cook. A bedroom needs at least one wall long enough to fit the size of bed that's envisioned, plus two end tables. The bedroom should be sized to allow a bed to be positioned where there can be at least three feet in front of the bed to pass by it easily.

The sizes of the rooms and the rooms' relation to one another will affect the organization and efficiency of the house's interior. Interiors chopped up by too many hallways or with oversized, unused entryways or ill-conceived stairways are wasting space. This is why you can never judge a house's interior solely by its square footage. There are countless examples of relatively small interiors that look, feel, and live larger than houses with much bigger square footage; it's all a matter of layout and design. Even if they have little experience in identifying efficient use of space, most people can easily recognize when a home wastes space on passageways. The next step is to understand that large rooms should avoid dwarfing people, and that rooms should not have proportions that cause occupants to feel as if they're in a deep pit (the result of too high a ceiling) or in a bowling alley (too low a ceiling). It's fine for a room to feel cozy, but not for it to be cramped. Even small rooms should be sized so that the walls do not feel like they are closing in on you from one side or another; thus they should be at least eight feet six inches wide. By reading magazines and books about interior design, a person can become familiar with good proportions and what they look like in a house. Pleasing proportions make spaces feel comfortable, not cavernous or inelegant. Well-designed, bright, airy interiors with nicely arranged windows and doors and correct proportions look great regardless of whether they have furnishings and decoration.

By reading magazines and books about interior design, a person can become familiar with good proportions and what they look like in a house. Pleasing proportions make spaces feel comfortable, not cavernous or inelegant.

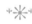

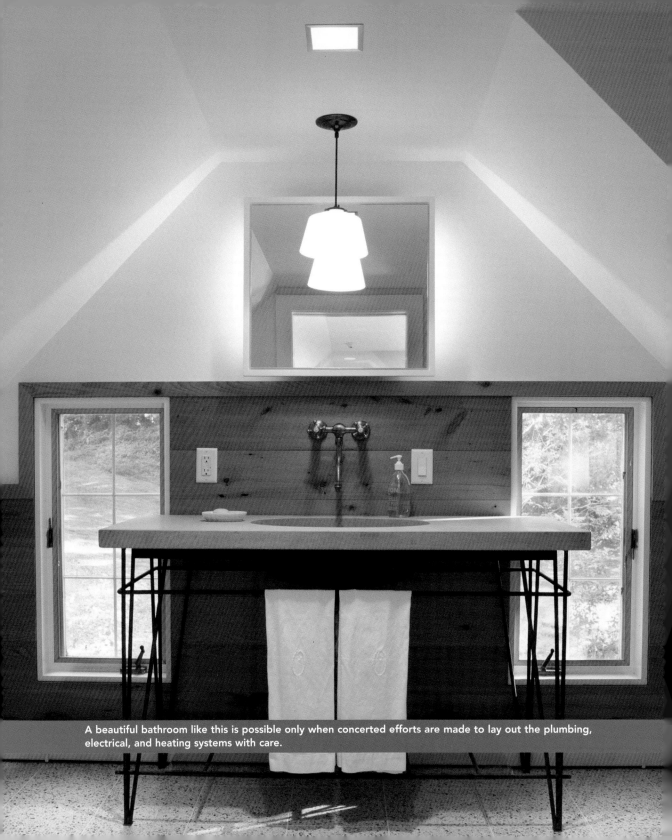

A beautiful bathroom like this is possible only when concerted efforts are made to lay out the plumbing, electrical, and heating systems with care.

We all like to think of our homes artistically, as having a look and feel that will put us at ease at the end of a long day and will make us proud when company comes to visit. Building a house, however, requires more engineering than artistry. Today's houses are extremely complicated entities, incorporating foundation, framing, and water protection systems; heating, venting, and air conditioning systems; electrical and lighting systems; and often audio/visual, data, security, and safety alert devices as well. In addition to the systems that relate to the interior of the home, an up-to-date residence has hook-ups and tie-ins to local telephone, cable, and power networks, to name just a few.

Most of these systems and devices lie underground, overhead, or behind the walls, and consequently they are easy to

Step 9

Looking Behind the Walls: The Systems

A home is just as much a machine as an automobile. You need to check the mechanical systems.

neglect. Yet they significantly affect the homeowners' budget and well-being. If they work improperly or if they fail, the health and safety of the occupants and the community may be put at risk. Ultimately, they will need to be brought up to an acceptable standard, regardless of the cost involved. Capable professionals are available to take care of these systems, but you'll feel more confident about a home's functioning and safety if you acquire some knowledge of the systems and the terms used to discuss them.

For example, in rural terrain and in some suburban areas, each household may have its own well to deliver water and its own septic system to handle waste from sinks, tubs, toilets, and washing machines. Well capacities vary greatly and are described according to the gallons of water that can be supplied per minute. Good, deep wells are valuable, and can

be expensive to improve upon or replace. The capacity of an independent septic system—relied upon by houses that are not served by a public sewer system—may be limited. Septic systems are evaluated according to how many bathrooms (or bedrooms) they can serve. So a careful evaluation of the capacity, quality, and condition of all independent systems needs to be done, paying particular attention to whether they can meet all of your future hopes for the house.

Good Engineering

More engineering goes into a house than you might think. Every new house, regardless of its size, depends on two kinds of engineering: structural and mechanical. Structural refers to beams, studs, bracing, and other elements that allow the house to remain sturdily in place even in the harshest weather. The structure of a home consists of all the house parts that make up the floors, walls, and roofs; they can be assembled from any number of materials, including wood, metals, masonry, and concrete.

Ample baseboard heaters can be easily overlooked but are critical to the room's comfort.

Every house rests on a foundation, which is the part of the home that extends into the earth to provide stability. At a minimum—which is only appropriate in warm climates—a contractor digs footings and pours concrete between them and around the perimeter to make both the foundation and the floor surface. This is called slab-on-grade construction. The best foundations provide for a space between the first floor and the ground. It can be either a space of short height (sometimes called a crawl space), or a standing-height space (which can be called a basement if it exceeds seven feet six inches). Foundations of this kind are called raised foundations. Having a space under the first floor allows for better separation between the living quarters and the harsh outdoors. All foundations are sized and shaped according to the soil conditions, which vary from location to location and are tested and verified by engineers and local building officials.

There are engineering standards for each type of structural framing system. They are regulated and adhered to by architects, engineers, and

builders. Wood beams holding up the ceilings are not random hunks of trees; they are elements that have been tested and found capable of withstanding particular loads and stresses. Many structural beams today are a series of strips of wood glued together or assembled from a combination of solid wood and plywood, performing more predictably than a beam cut from a single log. Solid floor and roofing beams and wall studs come in standard sizes called out by the width and height of their cross section, such as two (width) by four (height). The sizes of all the beams, whether wood, metal, or concrete, need to be properly calibrated to avoid sagging even slightly, so any sign of unevenness should be checked in a thorough house inspection. The inspection looks closely at the structural components that can be easily seen (such as exposed beams in the attic and basements and the exposed parts of the foundation) and the structural condition (the straightness of the roof and signs of cracks or slopping of the floor) of the home to determine if it is well engineered and well built. A poor report on the structural systems is not something to take lightly, and a follow-up study should be conducted to determine the expense of remedying the flaws.

HVAC Systems

"Mechanical engineering" refers to systems such as heating, ventilating, and air conditioning (HVAC). Manufacturers engineer the heating, venting, and air-conditioning systems, including exhaust fans and air conditioners. All these products are regulated by both the government and the industries that produce them and must be installed in ways that have been determined to function properly. How many such products are installed and where they are placed needs to be determined through a series of calculations that consider the indoor and outdoor conditions. Fans in the bathrooms and over the stove need to be sized and selected according to the odors and the quantity of air to be drawn out and according to the location of the exhaust. Where baseboard heaters are called for, their length and type must be scaled to the dimensions of each room, taking into account the room's exposure to cold winds or the warming sun. Government regulations guide all these decisions to protect the homeowners from carelessness or negligence. Only licensed engineers and licensed subcontractors are allowed by law to provide these design services and installations.

CHECKING THE SYSTEMS

A professional inspection will disclose the capacities of the heating system. Ideally, the inspector will also test the various systems. Each of the following elements should be tested for their performance:

Water: Most homes get their water from a municipal system. The water's quality should be tested. If there are problems with it, a central filtering system may need to be installed—an expense that is worth the cost.

Hot water: This is supplied by the house's hot water heating system, and can be tested to determine how much can be delivered in a specified time.

HVAC: Although government rules regulate the engineering and installation of home heating systems, some houses were built under earlier, less stringent guidelines, so performance varies widely. Some houses are difficult to cool efficiently because of their construction (too little insulation or too many gaps in the construction prevent cost-effective cooling of the home) or their systems (HVAC systems that are undersized will struggle to cool a house, wasting energy).

A house that's well built is much easier to heat and cool. Comfort and energy efficiency depend in part on preventing air from penetrating through tiny cracks and gaps in the house's perimeter. A number of kinds of insulation are available to blanket the walls, floors, and ceilings.

A house that has been wired for an extensive number of electronic functions, such as entertainment systems, security systems, and various control systems, is sometimes referred to as a smart house. These interconnected systems are only as good as the company that services them. Check references, for if they cannot be serviced, they may be worthless.

The range of comfort and control provided by various heating and cooling systems is broad. When house hunting, it's helpful if you know enough to determine what class of system was installed. In general, the more subtle the source of heating or cooling (i.e., the more quietly, gently, and uniformly the warmth or coolness is delivered) and the more control the occupants are given (through exact temperature and draft control in individual rooms), the more expensive it will be to purchase and install the system. The most luxurious and costly heating system is radiant heating—lines installed in the floor, to warm the entire floor surface and keep the sources of heat out of sight. Radiant heating is a wonderful amenity, often worth installing even if it can be afforded in only a portion of the house, such as the living room and bathrooms. The best air-conditioning system is also inconspicuous, running through the walls and ceilings and distributing its air through conduits called ducts and vents; these are sized precisely so that the cool air flows silently into the room without causing drafts or moisture at the vents. An air-conditioning system of this kind is most applicable to new construction. To be retrofitted into older houses, such a system must balance the need for comfort against the limitations of snaking through the original structure. What drives up the cost of whole-house air-conditioning most is the controls. Each area with its own temperature control is called a heating and cooling zone; the more zones a house has, the more machinery and conduits that are needed.

The same conduits that furnish cool air in summer may supply heat in winter. This kind of system is called hot air heating or forced hot air, since it's typically driven by a fan in the furnace. (An older system of gravity hot air is now uncommon, since it did a poor job of delivering uniform heat in large or rambling houses.) The more expensive systems offer ways to condition the air as well as heat or cool it—such as by adding or removing moisture or filtering dust, pollen, and allergens from the air.

Less expensive than hot air systems are hot water or steam systems, which give off their heat through radiators. Alternatively, radiators may obtain their heat from electric coils. In old houses, radiators tended to be bulky upright units, often placed below windows. Radiators today tend to be baseboard units, which occupy a small space along the base of the wall; they are also installed beneath windows and besides doors, because those are locations where cold air enters a room. Hot water radiators, radiant floors, and hot

air systems require a furnace, which is like an oven, to heat the water or air before it is sent to the rooms via conduits in the walls. The quality of furnaces varies with their technology, and affects their performance. The best furnaces, sometimes called boilers if they heat water, are quiet, have a long lifespan, and use fuel relatively sparingly.

Electric heat can be supplied without a furnace, but all houses need a source of hot water for sinks, lavatories (the preferred term for bathroom sinks), bathtubs, and showers. Heated water for these purposes is supplied from the boiler, if there is one, or from a separate hot water heater. There are also unit-type HVAC systems; the entire system is contained within a single piece of equipment similar to a window air conditioner. These are often much less expensive and much less effective than whole house systems, but a few are designed to be more efficient in special conditions. It is expensive and difficult to change heating and cooling systems or to add electrical capacity. Consequently, a house that has the best systems already in place—and has additional capacity for the future—can be a great find.

Alternative or environmentally friendly systems for providing for heating, cooling, and power can be a valuable feature of a home if these systems were designed, installed, and maintained properly. When effective, these systems benefit the environment and reduce a home's operating expenses because they use less fossil fuel. Nature can contribute to heating, cooling, and other power needs, thanks to devices such as windmills or geothermal mechanisms that take advantage of the constant temperature at certain depths of the earth. There are two methods for capturing the warmth of the sun for heat and power: passive and active solar designs, both of which are found in a sizable number of houses. Passive design does not require machines to get the benefit of the sun; the house is designed so that the sun enters the house during the day and its heat is trapped or stored inside, helping to keep the house warm overnight. Active solar design incorporates any number of devices, from simple tubing (which captures the warmth of the sun in liquids, either for heating or for hot water) to photovoltaics (which convert the sun's energy to electrical power). The effectiveness of any active solar design depends on the location and the number of hours that full sun is available. A call to a supplier of active solar systems or the local power company will reveal the relative success one can hope to achieve from these systems.

EVALUATING SYSTEM CAPACITY

Individual comfort levels vary. Some people prefer their house warmer or cooler than the norm. However, all houses require enough capacity to accommodate present needs and whatever additions and changes may be envisioned for the future.

The inspection should evaluate how much electricity is available and whether the systems could accommodate any plans that the homebuyer is considering. For example, is there capacity for additional large appliances (such as a washing machine or a dryer) or other equipment (such as swimming pool mechanisms)?

Heating systems other than electric baseboard units typically depend on gas or oil (or, very rarely, steam), either delivered through the pipes of a local or regional network or stored in tanks on the property. Gas may also run the stove and the clothes dryer. Electricity is the source for any air-conditioning or other power needs. A determination of system capacities is especially critical for houses not hooked up to municipal or regional systems.

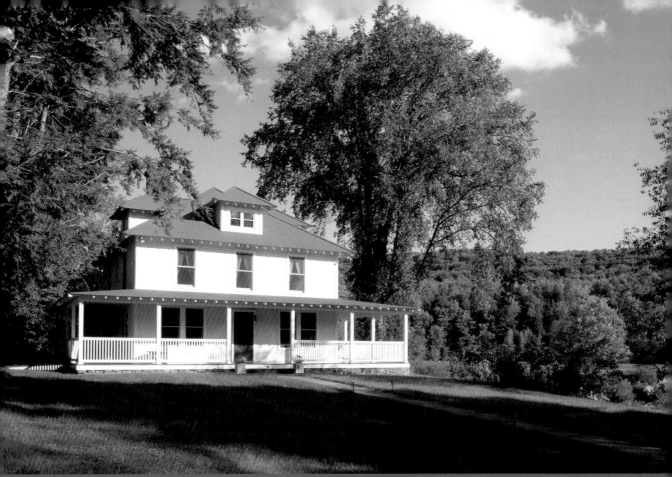

This old home was made new, and even better, by enlarging the wraparound porch. When a porch is good, there's no such thing as too much of it.

Hidden Treasures

🌷🌷 Diane and Dave love to hunt and fish, so they were looking for a home that would set them amid the best of both activities. They found a home on the edge of a great fishing stream, at the core of a hundred acres of woodlands. The home was a fine example of American Foursquare, with a simple layout that was well suited to the original farmers that lived there about a century ago. Best of all

was a wraparound porch that cried out for rocking chairs to rest in at the end of a long day in the wild. Diane and David knew that the house was in bad shape after years as a cheap

Whether to buy a particular house is sometimes such an intimidating question that people respond by taking one of two actions—buy it fast, or hem and haw until the property is gone. Part of the reason for this is the difficulty of evaluating a house's pluses and minuses. Analyzing a house is much more complicated than judging a stove or an automobile. You can't look up a home in *Consumer Reports*.

So how should you go about a house evaluation? My preferred method is to make a list with four headings: value, quality, convenience, and design. Those four categories cover all the key factors needed to decide whether a particular property is a wise purchase. I recommend grading all potential properties on a scale of one to ten or of "A" through "F" in each of the four categories. You'll end up

Step 10

Evaluating the Attributes: Positives and Negatives

Make three lists: what you like about the house you're considering buying, what you would hope to change about it, and what you dislike that cannot be altered.

with an organized and comprehensive assessment that will push you in the right direction.

Quality

Once you've narrowed the field to one or two properties, you should consult professionals who specialize in assessing the quality of houses. Prior to commissioning such a report, take a careful look around the property for hints of the quality of the house's construction and the care it's received.

Quality of construction is judged both by the materials employed and by the way they are installed. There are many inexpensive construction materials that detract from a house's quality. These materials may have a short lifespan, may be unhealthy to live with because of chemicals or other

boarding house and plenty of neglect. They intended to do whatever it took to bring it back to its former glory.

Besides their romantic feelings for it, they had a sound and sensible reason for wanting that old house at the edge of a stream: It would have been impossible to build there from scratch. Under current state environmental laws, a new home could not be erected anywhere near the streambed, which made up a good portion of the property. The old house beckoned as their much-longed-for dream home, which otherwise would have remained unattainable.

Diane and David's purchase exemplifies an aspect of good house hunting: finding a property with hidden value, in this case a precious location and a remarkable landscape, not to mention historic character. The couple reduced the size of the home, eliminating poorly built additions that contained unneeded space and that blocked the light and air.

Pared down and refurbished, the home was the size of what the farmers had built originally, with one exception. Diane and David decided, in rebuilding the wraparound porch, that you can never have too much of such a good thing, so they made the porch twice as deep. The family practically lives on the rockers on the porch, and the fish can practically jump from the stream straight into their laps.

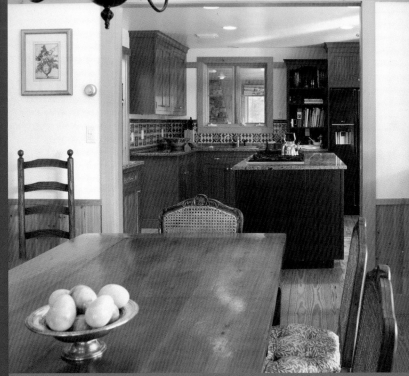

The original layout of this old house served just fine when complemented by a few new features, such as the double-wide doorway to the dining area.

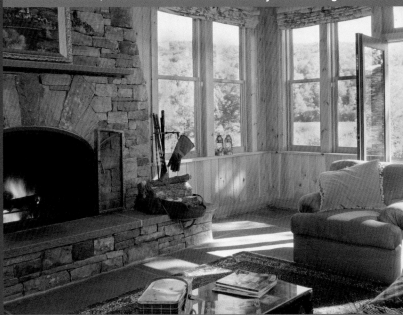

A new sun room/family room allowed the homeowners to have the big fireplace on their wish list yet not available in the old house.

substances involved in their manufacture, may simply look cheap. High-quality materials ordinarily make a home more satisfying to live in and less of a challenge to maintain. But no matter how expensive the materials may be, the skill with which they're used also makes a big difference. In fact, it's better to have a house of inexpensive materials expertly put together than a house of fine materials installed incorrectly or sloppily. Many architects have made a point of mastering the use of common materials. Some have created great houses, at relatively low cost, from plywood, sheetmetal, and other commodities usually regarded as low-grade. Adventurous homeowners sometimes get a kick out of seizing the aesthetic potential of prosaic materials.

To gain some familiarity with materials and their range of quality, you may want to undertake a little research. Many of my clients visit construction supply stores, browse in bookstores, and go on the Web. After not too long, they start to get a sense of materials and their capabilities.

If you look closely at a house, you'll almost inevitably pick up clues about the quality of its construction and maintenance. Gaps, cracks, and things that are crooked when they ought to be straight are bad signs, pointing to either inferior craftsmanship or poor upkeep. Keep in mind, however, that a house is a handmade product, so the way things come together in a house is rarely as perfect as, for instance, the way the door meets the body of an automobile or as the alignment of details in a refrigerator or stove. A hardwood floor may have small gaps between its boards and yet be well installed. But if the same floor has a wavy surface or has large gaps at the walls, there's a problem. If you find gaps where trim around windows and doors meet, or if you see cracks in most of the corners of the ceilings, you can safely classify the house as being lower quality. Also remember that maintenance, or lack of it, seriously affects a house's quality. All houses require upkeep. Mechanical systems must be routinely checked and cleaned; interior and exterior surfaces need to be freshened regularly; and diligent inspections must be conducted periodically for insects and mold. When a house is well maintained, it can survive indefinitely without requiring expensive repairs. Without maintenance, though, costly repairs may be imperative before you realize it.

Convenience and Design

To resolve lingering uncertainties you may have about a potential home, it's helpful to make a list of positive and

LOOKING FOR SIGNS OF GOOD CARE

One factor that merits strong consideration is how well the current or past owners cared for the house. When neglected, the components of a house may quickly deteriorate because of use and weather. Two houses of the same age—one carefully maintained, the other neglected—will present completely different long-term costs.

The parts of a properly maintained house will be in good shape. If that standard of care is continued, the house can go for many years without incurring substantial costs. Therefore, if an opportunity arises to talk to the sellers, inquire about what they did to maintain the house. An enthusiastic response from the homeowner is usually a good sign.

It isn't necessarily discouraging if a homeowner cannot name what was done to maintain the house, but if the response is less than enthusiastic, look for evidence of neglect. Any sign of water damage, such as mold, musty smells, a damp basement, or bubbling of paint on ceilings, is a source of concern and calls for a question to the sellers.

SIGNS OF QUALITY AND CARE

Every property being considered for purchase should be thoroughly examined by a professional house inspector. Each homebuyer should try to get a sense of the quality of the home and the care with which it was maintained.

Landscape

- Check the landscape. Does the property seem to have been well maintained for years or just recently cleaned up?

- Check the ground and paved areas. Are sidewalks or patios cracked? Is the landscape healthy and well maintained? Look for wet areas that may be a result of poor drainage.

- Ask where the property borders are and if the owners have a survey or a plot plan to confirm them. Walk to the edges of the property and see how they are maintained.

Exterior Surfaces

- Check the appearance of the roof. Does it show any signs of unevenness? Is the ridge line straight? Are shingles missing?

- Check the exterior surface or siding and window trim. Are there cracks in walls? Is the siding clean and tight against the wall, window, and door edges? Are there signs of rot or mold?

- Check the base of the house. If shrubs surround the house, look behind them. Are the materials at the bottom clean and dry?

- Check for gutters and see where they drain. Do they seem in good shape? If there are none, ask if there are foundation drains, and check the basement for signs of moisture.

- Check all outside doors. They should open and close easily. The hardware should be in good order. Check that the sills are well maintained.

Interior Surfaces

- Check the flooring. If it's wood, look at it closely and see if it seems solid. If it is wall-to-wall carpet or vinyl, ask if there is a corner where the carpet can be easily lifted to see the condition underneath. It is often plywood, and it should look dry, without signs of mold or mildew.

- Check the walls and ceilings. Look for any sign of damage from moisture. Evaluate the paint job.

- Check the trim, windows, and doors. All edges should be straight. Trim should be tight against the wall, windows should be easy to open and close, and doors should stay shut.

- Check the scent of the interior, especially basements and attics. All spaces should smell fresh, not musty. Look for signs of dust, dirt, or moisture buildup, especially around heaters and air-conditioning vents.

negative aspects of the house's design and conveniences. It's not uncommon for a few good or bad aspects of design and convenience to weigh too heavily on a homebuyer's outlook. The house hunters may have been impelled to look for a new home because of a small number of flaws in their current home: inadequate storage space or too few bathrooms, for example. In cases like this, the house hunters sometimes become so excited about finding solutions to those few inconveniences that they lose focus and fail to notice other attributes. That's why making a list of positives and negatives in the new house's design and conveniences is so useful: It brings to light factors that may have been underestimated or forgotten.

In compiling the list, think of the routine activities your new home needs to accommodate, such as doing laundry, working on hobbies, and cooking just to name a few. When a potential home seems to serve those activities well, those would be noted as positives. Aspects that fall in the negative column should be annotated with a remark as to how easily, or with how much difficulty, they can be fixed. Finally, convenience considerations should be weighted according to their relative value. A feature that comes into use infrequently, such as good accommodations for an occasional guest, probably deserves less weight than a convenience that regularly affects every member of the family.

Because "design" is so subjective, it's imperative that you take an analytical look at the positives and negatives of a home's aesthetic attributes. A house may have traits that suit your taste—it may be modern or classical or "country" and consequently make a good first impression—yet fall short when graded in comparison to other houses in the same style that have better designs. Foremost on the list: Is the house, taken as a whole, carefully designed? Does the house seem to be well thought out in its originally planning? For example, does it seem to fit its location well? Does it make good use of interior space and storage? Does it have an appeal that will likely endure? A house may seem aesthetically appealing at first glance, but turn out not to be attractive upon closer inspection. What's rare and valuable is a feature that is designed very unusually, yet possesses an appeal that will last. It is helpful, on the list of features that appear to be positive, to note whether each of them will stand the test of time. The house should be able to undergo a number of changes in furnishing and decoration without losing its appeal.

RECOGNIZING SIGNS OF TROUBLE

A professional inspection provides an important review of the quality of the construction and of the house's current condition. To get the most out of the inspector's report, it is important to know what to look for. Certain areas are afflicted by particular maintenance problems. Calling or visiting your local building department may help you identify those problems.

Local building ordinances are updated as problems with ground water, gases, pollution, insects, and other threats arise. If the house you're thinking of buying was built prior to some of the ordinances and has not been modified, it is possible that you will want or need to upgrade it. Some repairs and upgrades involve minimal cost. Treating a house for an insect problem or improving the house's ventilation are more or less routine matters, and need not be expensive. By contrast, problems that necessitate structural changes, such as modifications to foundations or framing or alterations to a house's mechanical systems, may be costly.

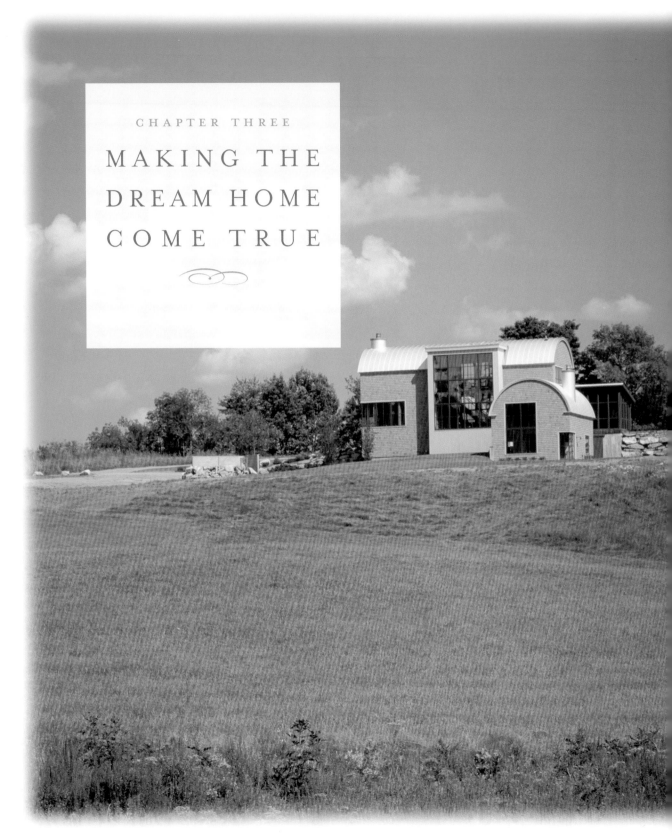

CHAPTER THREE

MAKING THE
DREAM HOME
COME TRUE

There's a difference between a house and a home. A house is mere material—wood, concrete, appliances, and so on. But after it's been fine-tuned to reflect the dreams, lifestyle, and imagination of those who live in it, the house blossoms into a home, a dwelling with spirit. Many small things can be done to turn a house or an apartment into an expressive and enduring home. If big changes are needed, just about anything is possible with enough time and money. Always keep in mind that the improvements should aim to produce not only more space or a new look but also a better lifestyle and a new excellence.

The most efficient, cost-effective path to transforming a house consists of sorting through the occupants' wishes, developing a strategy of when and how the chosen wishes can be achieved, enhancing the good features the house already possesses, and systematically carrying out the changes. Whether the house is newly acquired or has been in the family for years, it should be treated as a canvas for your vision. With the help of capable design professionals, it can become a dream home either through a piece-by-piece evolution or all at once in a "big bang" transformation. The keys to this domestic miracle are straightforward and simple to understand: Make lists, stay focused, take an organized approach, consult useful experts, don't cut corners, and do things right the first time. Throughout all of this, a commitment to quality is essential. Small dreams accomplished well are more rewarding than large visions that fall short in the execution.

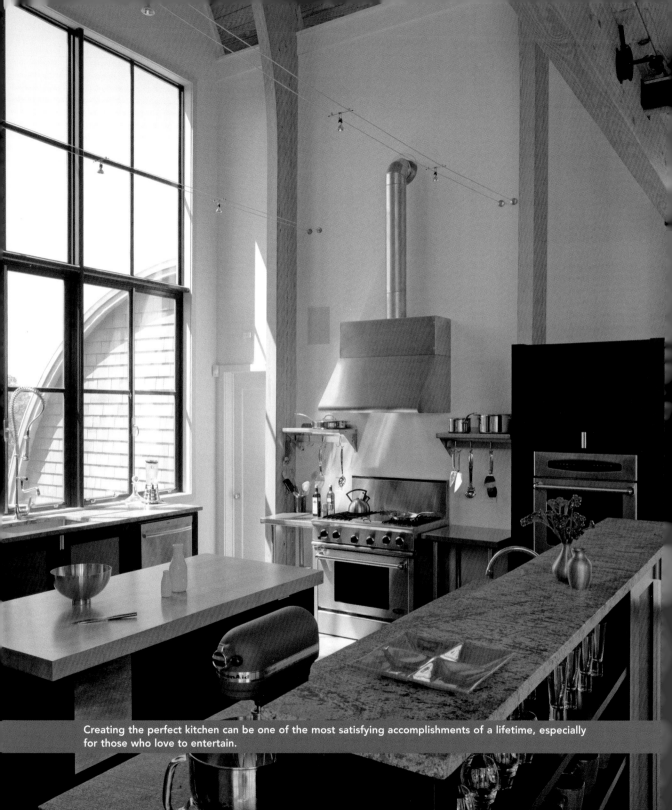

Creating the perfect kitchen can be one of the most satisfying accomplishments of a lifetime, especially for those who love to entertain.

For every wish there is a strategy. Some wishes are so simple and straightforward that a house hunter can easily grasp how to fulfill them. If a homeowner wants a bright, sunny interior, all that may be needed is a new window or a couple of coats of paint. Other wishes require more research and resources, but devising a plan for achieving those may still be relatively easy. For example, house hunters in New England who yearn for an old-fashioned saltbox Colonial should be able to find one without much difficulty, since saltboxes, with their balanced façades and their distinctive, long slope of roof at the rear, are plentiful in that part of the country. A family that cannot find an acceptable existing saltbox might build a new one or might purchase a house with a different shape and then remodel it into the essence of a saltbox.

Step 11
Fulfilling the Wish List

Never give up on the dream. Revisit all your wishes, and plan some way to satisfy the essence of each of them.

There are other wishes, though, that do not lend themselves to conventional answers. If you live in a cold northern climate and you love tropical houses, it would be foolish to create a home exactly like one you've admired that sits in a warm equatorial climate. However, you can find clever ways to give a northern cottage the look and feel of an island bungalow—by deploying deft choices of décor, architectural detailing, and even landscape design. When what you're wishing for requires an imaginative solution, this may be the occasion for creating a truly unique home. Interior designers and architects relish working with clients who offer opportunities of that sort. For a designer, nothing is more satisfying than creating a place unlike any other. Whatever your desire, every heartfelt wish—large or small, common or unusual—should be met with careful research

and a plan of action. You can put together a strategy for achieving your dreams if you take a systematic series of steps: collect and identify your wishes, prioritize them, and determine what resources will be required to fulfill them.

Redecorating Wishes: Changing Finishes and Fixtures

When trying to create the home that will be ideal for you, the list of wishes may be so long that you can't imagine accomplishing every one of them without a bottomless budget and an endless amount of time. To avoid being overwhelmed, you'll need to sort things out. Some wishes can be accomplished readily and affordably. Others will demand greater efforts. The wishes that are easiest to bring to fruition are those having to do with decorative finishes such as paint colors, light fixtures, cabinet hardware, and floor coverings (tile and wall-to-wall carpeting, for instance). Decorative finishes do not require the heavy construction work associated with other kinds of home improvements; they can be done over time, and in many instances can be carried out by the homeowners themselves.

The word "decorative" may sound superficial, but changing the fixtures and finishes can make a home more pleasant to live in and easier to maintain—and can sometimes make a home more healthful. For example, replacing inexpensive wall-to-wall carpeting with wood parquet tile may reduce the quantity of trapped dust and mildew in a room. Stripping old paint from trim can restore the crisp original profiles and remove unhealthy toxins. Some wishes will simply make a home prettier (which is not a minor matter), but others will do that and at the same time improve the home's quality.

The strategy for refinishing a home starts with collecting information on the fixtures and finishes and doing comparative shopping to understand all the associated costs, the comparative benefits, and the available warranties. A homeowner's wishes often reflect what has appeared in magazines or books; those images should be analyzed to find out what decorative finishes they require and to identify the paint palette or the hardware design that best reflects

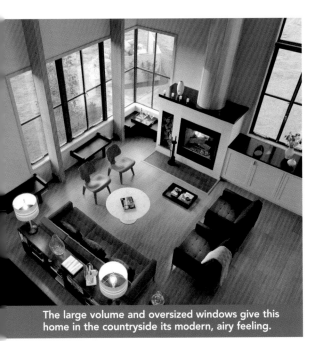
The large volume and oversized windows give this home in the countryside its modern, airy feeling.

your personality. When buying a home, a good strategy is to make only decorative changes at first. Personalize the home and improve its quality, but put off larger projects until later. This strategy allows you to live comfortably in the home for a few years, during which you will get a better feel for the full potential of the property. With time, you'll gain a realistic understanding of what might be achieved through more substantial improvements. A renovation budget of ten percent of the home's value (or less if the homeowners do the work themselves) should be enough to personalize an entire home, addressing every item on the wish list that has to do with decorative finishes.

Renovation Wishes: Layout and Architectural Renovations

Wishes that demand greater effort are those that aim to change the home's layout, its architectural style, and the relationship to its surroundings. These changes take place through renovation or remodeling, and require the assistance of professionals. Though more costly than decorative alterations, they typically produce results that are longer-lasting and more satisfying.

Well before calling in the professionals, the homeowners can begin the process by organizing their thoughts, carefully considering their aspirations, and whittling those wishes down to the essentials that are most achievable. You don't need to be an architect or an interior designer to look around a home and determine whether the rooms are ideal for your purposes. You can ask: Does each interior space offer enough room for the desired furnishings or for the number of people it should serve? "Space planning" is the term that designers use to describe the process of determining how the interior of a home is laid out.

A neighbor in my condominium building purchased a cramped one-bedroom apartment in which the entry was flanked by a tiny galley kitchen and a bathroom and led to a living room that was flanked by the bedroom. The homeowner's interior designer recommended altering it to a more loft-like plan so that he could entertain large gatherings. He removed the walls between all the rooms (other than the bathroom), creating one large space. The new "loft" layout not only serves his entertaining needs better. It's also brighter and more comfortable, even when he's home alone.

MAKING A MASTER PLAN

The right time to start planning additions to a home or changes to its landscape is when you first recognize that those improvements may eventually be needed. The more consideration and research invested into these ideas, the more likely they will be realized effectively.

Developing a strategy for everything that might ever be desired on a piece of property is called master planning. Master plans can be created with the help of a residential architect, a landscape architect, or both. Just as with planning a home remodeling, creating a master plan for a property requires you to gather thoughts and images of what your ideal property would be.

The designer can translate these wishes into a diagram for the future—such as changing the driveway, removing a stand of trees, or altering the contours of the ground. Landscape changes can be costly, and planting can take years to mature, so it may be best to start some of the landscape improvements soon and make additional ones periodically.

～WISH LIST～

TURN YOUR WISHES INTO A PROGRAM LIST

Every homeowner should take time to write a wish list of everything he or she always wanted in a home. This exercise is an important first step toward achieving your goals and aspirations. Key information on the wish list can then be reorganized into a list that describes the goals of the improvements or renovations.

Architects and interior designers refer to the latter as the program list. Below you will find a sample program list and the corresponding thoughts on the original wish list. Take your wish list and see if you can create a program list that outlines what is needed for a renovation or an addition of one or two rooms.

MY WISH LIST

- I would like a good area to store wet boots, coats, and umbrellas that is out of sight of the kitchen, but nearby. It should have a place for book bags, keys, and a place for the mail.

- I would like a dining area for just us, and an area to accommodate large gatherings, possibly as part of the family room.

- I like to feel connected to the outdoors where we eat, possibly by a window or a pair of doors that opens to the scenery.

- I would like the kitchen to be open to the dinning table but I do not want to see the dirty dishes from the table.

- I want to have a better kitchen layout that is really functional, where I can see everything—not hidden by solid doors—and lots of counter space. A place for stools, too.

- I want a big sink and I want to see outside when I do dishes.

- I would like a comfortable, rustic feeling with exposed beams, for example, and an old-fashioned wood stove.

PROGRAM FOR KITCHEN/FAMILY ROOM RENOVATION

- New mudroom, with cubbies for storage, and a shelf for mail. Room should have washable surfaces, coat hooks, a boot bench, and an umbrella rack.

- The mudroom should be adjacent to the kitchen.

- New kitchen with an intimate area for dining—breakfast nook with windows. The layout should contain an island or peninsula section for stools.

- Kitchen should be fitted out with open shelves for storage and/or glass doors, a hanging pot rack.

- Kitchen layout needs to accommodate a large sink with a window over it and a wood stove.

- Kitchen should have a large opening (with possibly a wood beam over it) to the family/dining area, but the layout needs to assure that the sink can not be seen from this room.

- Dining area in family room should accommodate ten to twelve guests and be adjacent to either French doors or a bay window with a good view of the landscape.

When the opportunity arises, nearly every home would benefit from a renovation that improves its connection to the landscape or surroundings. No matter how well a home is originally designed or constructed, over time changes occur in the landscape; often they justify making a change in the home's exterior. For example, a house that was originally built with a front porch looking toward a quiet road and a sunny meadow now may face a busy road and a landscape that's urbanized; yet the grounds at the house's rear may have matured and become more bucolic through the years. Adding a new porch to the rear of the house could be the best way to personalize the home, add space, make better use of the property, and perhaps improve the home's overall appearance. Many homes are built from standard plans with no specific location in mind. As a result, a wall devoid of windows may face a pretty brook or may occupy the location that would catch the most breezes. In a situation like this, adding or repositioning windows to seize the potential of the surroundings is not only a smart thing to do; it also makes otherwise uncomfortable rooms enjoyable to be in, without investing in extensive decorative work. No matter what the size of the budget, the owner can explore ways to take better advantage of the surrounding environment and thereby dramatically improve the home, with the help of an architect.

Most Complicated Wishes: Systems

The most complicated and potentially expensive changes tend to be those having to do with mechanical and electrical modifications. Homeowners sometimes want new heating and cooling systems, to improve the comfort level and to obtain other benefits, such as easier maintenance, a healthier environment, and lower monthly costs. New cooling systems incorporate technologies that can remove dust particles as well as reduce the humidity. Radiant heat, which warms the floor of a room or an entire house, can make any room feel warmer while using less fuel. Upgrading an older home's electrical equipment can significantly improve its performance and safety. Through mechanical and electrical improvements, homeowners can help the environment at large, for a more efficient home saves resources and pollutes less.

 One way to accomplish goals on your wish list is to translate your thoughts into spatial studies. This can be done by diagramming the shape and size of a room on a piece of grid paper, using one-half inch to represent each foot. Then, by placing scaled-down cut-outs of furnishings on the diagram, you can see whether the desired use can be accomplished within the existing dimensions.

Make files of decorative wishes—those regarding finishes and fixtures—and organize them according to each of the house's rooms and your priorities.

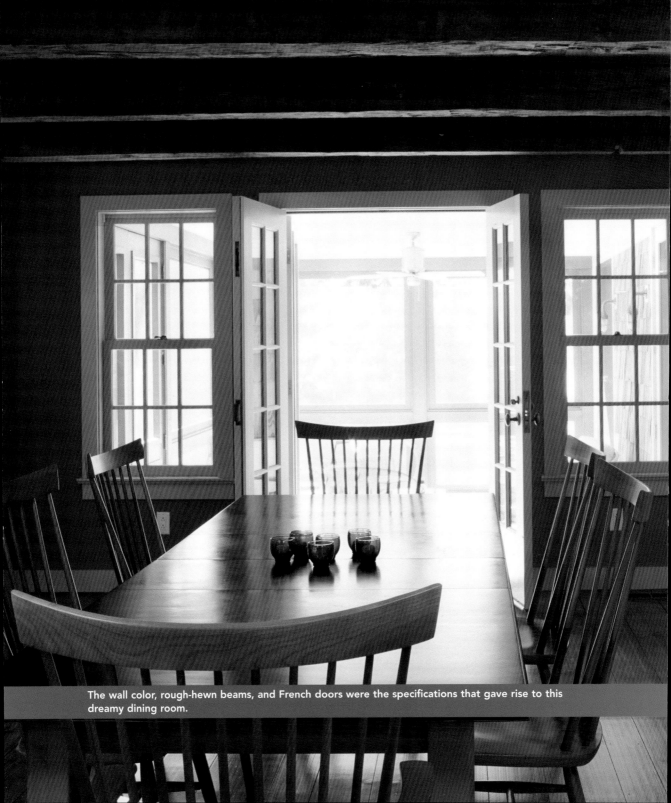

The wall color, rough-hewn beams, and French doors were the specifications that gave rise to this dreamy dining room.

"God is in the details," said Mies van der Rohe. The modern master was right. To make a home comfortable and enduring, its owners must pay attention to many details, ranging from doorknobs to the paint on the walls. Well chosen details will make a home more pleasurable to live in and will add to its value. Though not everyone has the time or money for a major renovation, it is possible to improve a house bit by bit. A good paint job can make rooms brighter, richer, and easier to clean. New door hardware, faucets, and light fixtures can reinvent the style of the house's interior.

When architects or interior designers work on projects, they spell out the quality and the particulars of the details in what are called "specifications." Specifications are a tool that homeowners can use to make improvements in the most

Step 12
Fine-tuning the Specifications

Be methodical; consider every surface and corner of the home, and, piece by piece, plan on personalizing it with your own touch.

cost-effective way possible. Homeowners can sort through their options and—preferably with an architect or interior designer—come up with specifications that will help create their dream home. We live in a period bursting with choice, so usually the options are numerous. Discovering which options will make the best contribution requires research, comparative shopping, and sometimes testing.

Specifying a Good Paint Job

The most cost-effective improvement a homeowner can make is a good paint job. The interior of a home presents a series of surfaces—floors, walls, and ceilings—and they acquire a wonderful richness when finished with high-quality, long-lasting, and well-applied materials. An important but often

Exteriors of old homes, just like their interiors, can look new when given a high-quality paint preparation. The specifications should stipulate that the painter will restore all trim to its original shapes; even out the siding and patch it; seal gaps around all windows and doors; and repair or replace waterproofing and flashing.

Always specify nontoxic materials and good construction habits so that you get a healthy home improvement. Let rooms air out for a few days or even longer when possible. Insist that workers remove all chemicals and compounds from the home at the end of each workday.

overlooked aspect of paint is that it provides the finish and protection for most of a house's surfaces.

Paint finishes vary in hue and smoothness. They also vary in the quality of the ingredients and in the application. This quality, in turn, affects the interior's final appearance, ease of maintenance, durability, and the house's value. Proper preparation is indispensable. A new coat of paint on a wall or ceiling that has not been suitably sanded, cleaned, patched, and primed will not last as long as one applied to well-prepared walls, nor will it achieve the full potential of the finish. Correct preparation should even out walls and ceilings, return old trim to its crisp original shape, and give inexpensive new trim a smoothness that can be luxurious. A high-quality professional paint job may cost more than an amateur one, but it will look new for years longer.

The key to getting the best results from paint is to be specific about the goals—not just the room's decor but the use of the room and the desired effect. Certain paints stand up to wear and tear and to regular cleaning better than others. You can find high-quality nontoxic paints that are made with natural pigments. They're ideal for children's rooms and for the home of anyone seeking a healthier indoor environment. Glossy and satin finishes are tougher than flat finishes; that's why they are often specified for trim work and for rooms that get harder use. Where a brighter, sunnier atmosphere is desired, a high-gloss finish on the ceilings may be worth the required preparation. (The shinier the finish, the smoother the surface needs to be.) You can paint just about anything but it is wise to do a test before applying paint to surfaces that were not painted previously, such as wood floors. One good thing about paint is that if you don't like the results, you can nearly always put another coat over it.

Hardware and Fixtures

Some people have a knack for noticing details. Some don't. But the look and feel of a home depend on the little things, like the doorknobs or the sink faucets, even if the homeowners or guests are not consciously attentive to them. It is not true that details like these need to be expensive for a home to have a dreamy look or to possess a lasting appeal. I admire homeowners who choose simple brushed chrome doorknobs of a good commercial grade. These doorknobs are not fancy by any means, but they are well engineered, they resist

scratches from rings and keys, and they come in beautiful globe, egg, and lever shapes. The best way to gain a sense of what would be both pleasing and durable is by comparative shopping, observing what is used in homes you admire, and sometimes doing additional research.

Quality is important for all hardware, from knobs to hinges to kitchen cabinet pulls. Quality is important, too, for kitchen and bath fixtures, such as faucets, towel bars, and robe hooks, and for electrical fixtures, such as outlets and light switch plate covers, wall sconces, ceiling lights, and recessed lights. All of these are working parts of a house. They will last longer when they are of more than minimum quality, and they will give the home an overall appearance of distinction.

Besides insisting on quality, the homeowner must select a palette for all the hardware in a home. This is akin to deciding whether to wear either gold or silver. The goal should be cohesiveness. This can be accomplished by specifying one finish for all of the home's hardware and fixtures. If you prefer a variety of finishes, guidelines should be established that will maintain a degree of aesthetic order. The guidelines could dictate that all exterior doors will have hardware with a dark bronze finish, while all interior doors, plumbing, and electric fixtures will be a light brass. Sometimes the finishes on different wings or different floors of a home can be assigned separate specifications. Those might be appropriate to the overall character of a portion of the house—less fancy on the second floor perhaps—or to the architectural style.

The style of the details can establish or reinforce the overall character of the home in a subtle yet significant way. A home possessing a hint of bungalow can strengthen its character if all the hardware and fixtures are replaced with elements reminiscent of the Arts and Crafts period. Conversely, a condominium in an older building can be made to seem more modern by converting its details to those with a contemporary design. If the owners of the aging condo dream of having a more modern one, they could complete the transformation by specifying satin and high-gloss paint in monochromatic colors on all the surfaces. The character would emerge entirely from the details.

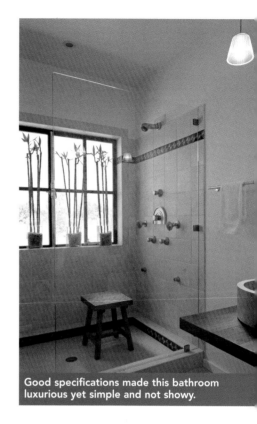

Good specifications made this bathroom luxurious yet simple and not showy.

Mockups and Samples

Special finishes, such as unusual paint colors, the painting of patterns on a floor, or painted textured surfaces, require

additional research and a few test runs. "Mockups" are the designers' term for test runs done to models built of materials matching those to be painted. For example, a knotty pine floor that's to be painted a checkered pattern could be tested on a series of two-foot-by-two-foot models built of short knotty pine floorboards. With mockups, a selection of paint brands, applications, and finishes can be tested quickly before committing to the entire project. Mockups should always be viewed in the space that is to be treated. In other words, if the floorboard mockups are made and painted in a shop or a garage, they must be brought into the room whose floor is to be painted. The light, the colors, and everything else about the room will exert an impact on the way the final finish will look. If the mockup is viewed elsewhere, it isn't a true test

Another instrument for decision-making is samples. Samples are either small pieces of material or actual house parts that represent the hardware or fixtures specified in a home improvement. Most products available through mail order can be obtained in sample form. Usually the samples are small pieces of material that are supposed to match the color and finish of the product you're considering buying. It's helpful to collect samples during the early stages of considering what to specify. However, when you're ready to order a large number of house parts, such as replacements for all the door or cabinet hardware, it's worth buying one piece, to make sure it's what you expect. This is the truest test for determining whether you'll be pleased with it. You might even consider installing one of the sample parts and living with it for a while to get a feel for it and to see how it stands up to its intended use. Never select a house product solely from a picture in a catalog or an image in a magazine; the photo cannot reveal its quality or guarantee that you will be satisfied. Only a sample can do that. Also, manufacturers often change the design and construction of household products; this is rarely apparent in the catalogs and the change can occur without your knowledge. If the manufacturer or supplier provides you with a sample but the other parts do not match it, the maker is required to take it back.

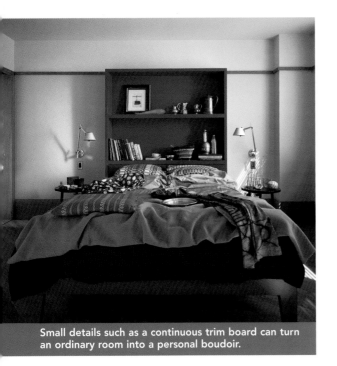

Small details such as a continuous trim board can turn an ordinary room into a personal boudoir.

SPECIFICATIONS
KEEP YOUR THOUGHTS ORGANIZED

Whenever my firm makes plans for remodeling or for building a new house from scratch, we produce a specification chart for all the rooms. This is an organized way of calling out the treatment of every surface and key details. See how you would fill out the specifications of the rooms in your dream home.

	FLOORS	WALLS/CEILINGS	WOODWORK: DOORS/ WINDOWS, CABINETRY	HARDWARE
FIRST FLOOR				
Entry	Spanish tiles	Wallpaper. Painted ceilings: white throughout first floor	Mahogany front door. Painted trim windows	Brass front door hardware. Brass light
Living/ Dining Room	Stained oak— wide planks	Painted walls: pale blue	Painted trim windows and doors. White-painted built-ins and bookcases	Bronze door and window hardware
Kitchen/ Family Room	Stained oak— wide planks	Oak wood wainscoting: natural. Top painted yellow	Wood trim windows and doors: stained oak. Painted kitchen cabinets: mustard	Brass door, window, and cabinet hardware and kitchen faucet
Powder Room	Marble tiles	Painted wood wainscoting: white. Top wallpaper	Painted trim windows and doors: white. Painted vanity: red	Brass hardware and fixtures
SECOND FLOOR				
Master Bedroom	Wall-to-wall carpet	Painted walls: cream	Painted trim windows and doors: white. Painted built-ins and bookcases	Chrome door and window hardware. Marble counter
Master Bathroom	Marble tiles	Marble wainscoting. Top wallpaper	Painted trim windows and doors: cream. Painted vanity: pale green	Chrome hardware and fixtures
Children's Bedroom	Oak— narrow boards	Painted walls: blue	Painted trim windows and doors: white. Painted built-ins and bookcases	Chrome door and window hardware
Second Bathroom	Ceramic tiles	Painted wood wainscoting: blue. Top wallpaper	Painted trim windows and doors: white. Painted vanity: white	Chrome hardware and fixtures. White countertop

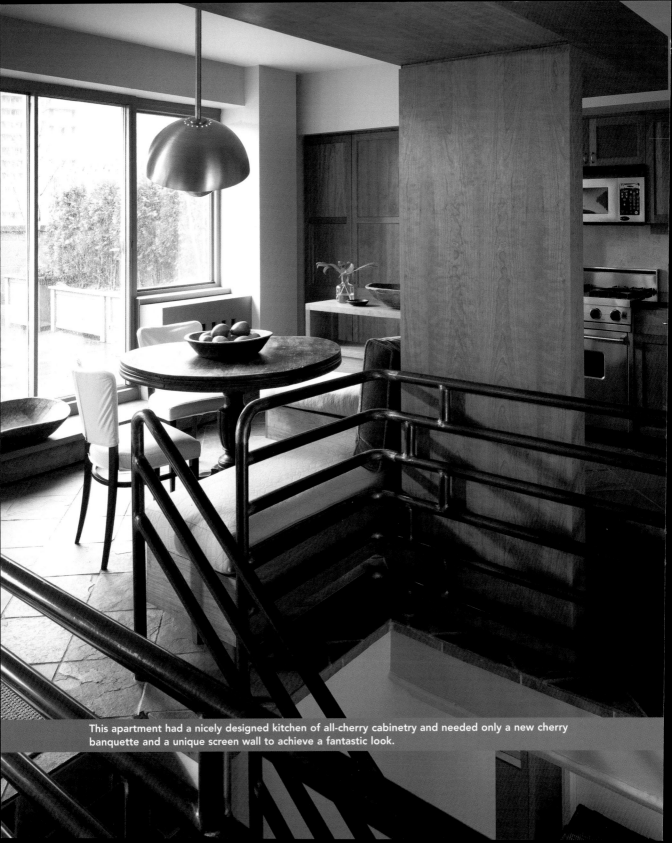

This apartment had a nicely designed kitchen of all-cherry cabinetry and needed only a new cherry banquette and a unique screen wall to achieve a fantastic look.

What's the best way to spend money improving a home? Accentuate the appeal of the home's best features and characteristics. It's not easy to come by spaces that are efficiently laid out, rooms that are filled with natural light, and exteriors that are rich in character. So if those qualities are already present in your home, make the most of them.

When changes are needed to realize your concept of the dream home, choose alterations that will not damage the existing positive attributes. For example, if you're set on adding a screened porch, take pains to build it in a location where it will make optimal use of the landscape and won't detract from the home's interior. Sometimes people make the mistake of adding a porch that throws the adjacent rooms into shadow. Even when the house seems so inadequate that a

Step 13
Building Upon the Strengths

Understand that the best return on improvements to a home comes from making the good points even better— inside, outside, and in the landscape.

substantial renovation is unavoidable, there's value in carefully assessing every positive attribute. So look at the home analytically, determining which rooms might be improved with the smallest of changes. It always makes sense to spend money and resources judiciously, improving the parts of the house that could most use some help.

Strengths of the Layout

A home typically consists of a series of rooms and hallways, set side by side to fit within the outside walls, like the pieces of a puzzle. Puzzles can be cut into any number of pieces and an unlimited assortment of shapes. To some extent, a home can be, too, by moving walls, combining, or dividing rooms. When pondering a home improvement, I find it invaluable to study

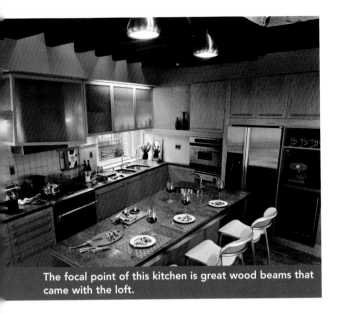

The focal point of this kitchen is great wood beams that came with the loft.

the floor plan. The floor plan enables a person to make the most analytical assessment possible of how the home is laid out; it supplies all the crucial information, showing each room's outlines, dimensions, and placement. To understand a layout's strengths and envision the possibilities for building upon them, it's useful to take notes about the things you view as the layout's positive attributes. If part of the house is particularly sunny, a room has a great view or is the most quiet place in the house, or an area offers the best storage, jot down a couple of words about those assets.

It can be revealing to review a floor plan and ignore all the room labels. Rooms don't have to be used for their current purposes—bedrooms can be used as playrooms, dining rooms can become libraries, even kitchens and baths can be refitted for other uses. Perhaps a bedroom in the quietest corner of the house would ideal for a home office or a yoga room. That's what I mean by building upon the house's strengths.

A client of mine bought a lovely old home with a fantastic view of the Hudson River. She wanted to upgrade the kitchen and the living room. The kitchen was in the newest part of the house and had the best view, but was ugly inside and out. The living room was located in the historic part, with an original Colonial fireplace, but was long and narrow, which didn't suit its purpose well. In a renovation, we flipped the locations of the rooms, constructed an all-new wing where the kitchen had stood, and adapted the historic living room into a country kitchen with a great old-style fireplace. The rearrangement took advantage of the way the home sat on the property. In its new location, the kitchen gets both morning and evening light, and the living room has windows and French doors opening straight onto the garden.

Strengths of the Architecture

Even the most modest home may have exterior features and character that make its architecture noteworthy. My own home is only 800 square feet and was built on a very tight budget, yet it managed to win national awards, make the pages of national and international magazines, and be featured on

television. I'm proud of my house's uniqueness, but it is actually composed of many features found on traditionally designed houses all across the country: clapboard siding, double-hung windows, porch columns, and old-fashioned dormers. Beautiful elements can be found in modern-style houses as well: large overhangs, continuous bands of windows, and crisp masonry or stucco walls, among others. Houses with a strongly regional appearance, such as the Spanish Colonials of Florida, the classic bungalows of California, and the weathered gray-shingled Cape Cod dwellings of Massachusetts, have an authoritative architectural presence. Less common are houses with a distinctive architectural character on the interior, but when these do occur, the effect can be incredible. Examples range from eighteenth-century Georgian interiors, to the decorative Victorian and Arts and Crafts detailing of the nineteenth century, to elegantly spare modern interiors in the twentieth century. Even when only one room has such character or when there are only a few good details in the house, it can be worthwhile to preserve or restore these strong points.

The most common mistake in a home improvement occurs when the homeowner saps the strength of the architecture, replacing bits and pieces in an attempt at updating the house or at minimizing its maintenance. Too often, when interiors are refurbished or redecorated, the old details are discarded because they have seen better days. When moldings are removed, high ceilings lowered, or wood floors covered over, valuable features of a home are trashed or hidden from view. A good painter and carpenter can restore an interior to its former glory. The payoff is great, because re-creating such details from scratch would probably cost much more. The most talented interior designers successfully blend the style of the home's architecture with the homeowners' taste preferences. Exteriors of well-designed houses of all periods and all price ranges have been made ugly over the years, not through neglect but through improvements such as replacing good wood siding with characterless vinyl, ripping out attractive, sizable windows for new ones that are smaller or poorly proportioned, and adding additions or dormers that destroy the homes' original appeal. Some changes that lessen the maintenance costs end up reducing the house's curb appeal—causing it to lose some of its value on the market. Homeowners benefit all around by making changes that satisfy the owners' needs and build upon the strengths of the original design.

 Interiors that put their windows to optimal use have been proven to be healthier. Discover ways to arrange the interior to take advantage of the sunlight, fresh air, and views they provide.

Reduce the maintenance responsibilities of an older home by investing in a careful refurbishing of the original materials rather than replacing them with inferior synthetics. Not only will you benefit from the results; you may also encourage neighbors to do the same. Neighborhoods made up of well-restored homes command higher property values.

Over the years, homeowners should make improvements that take advantage of all the outdoor spaces they may have: front yards, back yards, decks, porches, terraces, and balconies. Maximizing the property's strengths will result in a place that's pleasing to live in and that will command the highest possible resale value.

Moving up Instead of Out

‡‡ Chip and Leanna each had their own apartments before they married. Although they both were comfortable with Chip's neighborhood, his apartment was too small to accommodate them in addition to Chip's big dogs and his home office. Rather than move to a fancier location, which they could have done with their combined resources, they decided to look for an apartment that was nearby but better sized—for everyone.

At first they searched for a much larger property, but none seemed quite right, so they concluded that the best investment would be to combine two smaller, affordable apartments—investing in a remodeling so that the merged space would offer a place for everything. They removed a

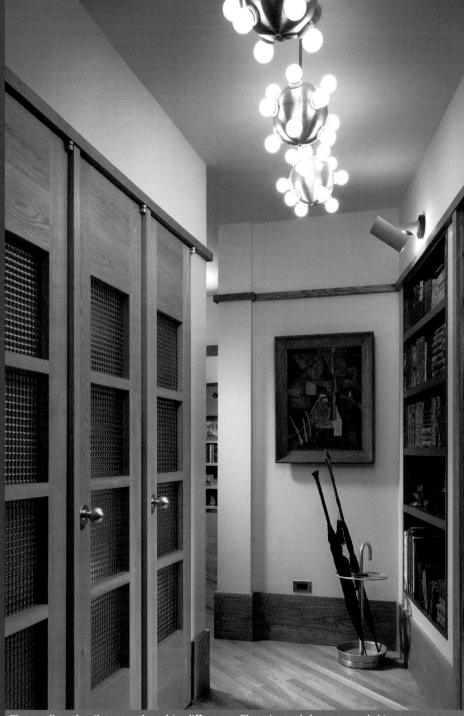

The smallest details can make a big difference. The trim and doors turned this narrow hallway into the most useful spot in the home.

A joke I tell about being an architect and buying my first condominium is that I had the kitchen renovated twice before I moved in—and this was in a brand-new unit in a brand-new building, one that nobody had ever lived in before. Designers love to make adjustments. It is through tailoring that a home is made to look great, feel comfortable, and work well. The condo I purchased was nearly perfect for my partner and me. It had the right size, the right location, and the right price. Because we purchased it pre-construction, we were allowed to make minor adjustments to the layout of the kitchen—what I like to call its first renovation. Just before moving in, I knew I would want to have the apartment worked on by my favorite painter, not only to add color and textured wall coverings but also to

Step 14
Achieving Dreams by Making Minor Adjustments

Consider strategic little changes that can go a long way toward turning a good home into one that's just perfect.

refine the woodwork as only a good finisher can do; and I had set a budget for doing that.

Because the penthouse units were not yet complete, the building took longer to open than we anticipated. By then I had the resources to make a few additional adjustments—the second renovation. I used that opportunity to create more of an opening from the new kitchen to the entryway, so that both those areas would feel more spacious. I added mahogany crown molding, mahogany hardware, and a mahogany bookshelf to the kitchen cabinetry, so the kitchen would be attractive to look at when people walked into the apartment. I also replaced the single-entry closet door with a pair of "hidden" doors to provide better storage access and at the same time reduce the closet's visual impact on the entry. Last, I added a set of French doors to the

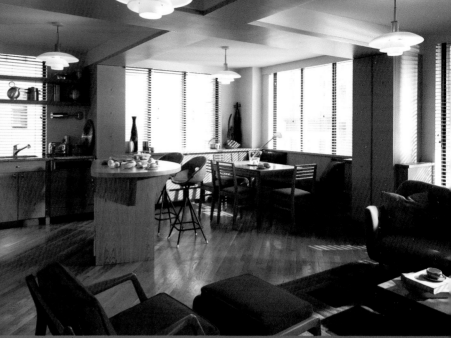

The owner added color and texture (with the wood paneling), a ceiling detail, and new light fixtures to give this room its personality.

few walls as part of the transformation, but their goals were accomplished mainly by selecting new finishes and making good on their love of built-in storage.

Good dream home planning and careful research helped them determine exactly what they needed and what would do the trick. Cabinets line the entry, with a drawer, cubbyhole, or shelf for everything from keys to leashes. Combining three smaller rooms created one large room that serves as kitchen, dining area, and living room—it, too, is lined with built-ins for seating, storage, and cooking wares. All the finishes look elegant, satisfying Leanna's love of sleekness. Yet the surfaces are tough enough to endure the roughhousing of Chip and the dogs. They customized their bedroom and bathroom and Chip's den with all sorts of special mechanical and

entertainment systems for everyone's enjoyment.

Because Chip and Leanna were so organized in their thinking and knew their personal requirements so well, the design and execution of the renovation went smoothly. This is an aspect often overlooked in deciding whether to move or stay and renovate: When the unknowns are reduced and decisions can be easily made, creation of the dream home proceeds more calmly and predictably, which translates into reduced stress, a shorter construction period, and less money spent. Chip and Leanna got far more home for their money by staying put and staying on the small side, doing the utmost with the resources available to them.

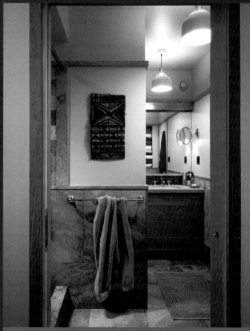

The combination of wood and stone make this bathroom as elegant as one in a fancy hotel.

passageway from the entry to the living room so that the living room could double as a guest bedroom. These were all minor adjustments, but they were not just decorative; and although they did not add up to a large construction project, they did require a well-conceived plan and a good contractor to coordinate the work.

Where Minor Adjustments Count

Sometimes it's easier to imagine a big change, such as creating an entirely new eat-in kitchen by adding a new section to the house, than it is to make a less dramatic adjustment, such as doing something within the house's existing footprint. Yet adjustments and small improvements are always preferable to major renovations. Why? Because within a fixed budget, smaller endeavors are able to achieve results of a higher quality.

The easiest way to find out whether a small change can accomplish your dreams is to look closely at every corner of a room and imagine what would happen if the room were slightly different. Pretend, for example, that you can see through the walls. Notice whether what's on the other side of the wall might improve the room. If it's an exterior wall, would there be a better view, a more convenient connection to the yard, or access to refreshing summer breezes? Is there a section of the room that's underused because of the swing of the closet doors or because this part of the room has a heavy traffic pattern? Would removal of a walk-in closet make a bedroom large enough to be used as an entertainment room? Could adding walls of bookshelves, window seats, and built-ins transform a little-used formal living room into an intimate library or den? This kind of rethinking of interior and exterior is the best way to discover the home's full potential.

Sometimes the appearance of a home can be dramatically improved through a few minor changes. My favorite renovation included a small change that I made to a house's front entry. The home had been constructed from a set of house plans used for houses all across the country, and the owners wanted to make the house special. The house's design was so common that just mentioning that it had the standard arched window set over the front door is enough to describe it. It was identical to many of the neighboring homes. We replaced the by-now-prosaic arched window with

Sometimes the appearance of a home can be dramatically improved through a few minor changes.

a round custom window and we added a small covered porch that fit the style of the rest of the house.

Some older homes have windows, doors, porches, or stoops that have been added over the years and that obviously do not match the original style. Remodeling or replacing these discordant features demands more effort in the planning stage than in the execution. Researching what the house originally looked like can be accomplished by driving through the area and looking for houses that were built in the same period and that have not been altered. It can also involve looking through books that focus on similar styles. I have even had luck at contacting the original owners and asking them for old photos of the house. Making minor changes to landscape features can also enhance the exteriors of any home, new and old. A new stone terrace outside the front door, a garden gate, or a new brick pathway may be expensive but these are relatively easy changes to carry out, and they can make a big difference.

Good Plans, Good Builders

Minor adjustments can do much to turn a so-so house into a dream home. They may be worth the expense even if the amount of money involved initially seems a lot to spend on a small area. For example, adding a set of large windows to a side of a house that has the potential for a view or abundant sunshine can make the interior more pleasant and can also make it feel more expansive. It's usually worth the investment. Similarly, it may seem costly, considering the fact that no space is being added, to take down a wall between two rooms. Yet by combining a formal dining room with a smallish parlor, you may be able to obtain a great room that's a superb gathering place.

To get the best results from changes like these, it is essential to test the ideas with the help of professional home designers, such as architects or interior designers. The investment in their services will not only help you to avoid making costly mistakes, but will also allow you to achieve a better result for the same construction investment. Architects and designers do this by taking the homeowner through a systematic process of translating the general ideas for improvements into very precise documents. The more specific the information, the better the chance that the builders can make constructive recommendations of their

Making minor changes to landscape features can also enhance the exteriors of any home, new and old.

own. This also allows the builders to be more efficient in pricing and in getting the work done.

The deceptive thing about small renovations is that they seem so straightforward and uncomplicated but often are not simple at all. It might seem that you could point to a window or a wall and say, "Make the opening larger." This is rarely the case. In some instances, an in-depth inspection of existing conditions is necessary to test the idea. This might mean that the contractor has to drill test holes to explore the structure and systems of the house that would be affected by the change. (Test holes should only be made by a capable contractor. Electrical, mechanical, and plumbing systems are close to the surface, and they could be severely damaged.) Without proper planning, costly mistakes can be made.

Every renovation project should be backed by a thorough contract that refers to the drawings and specifications completed by the architect, interior designer, or engineer. A good builder, when asked, will recommend that there be a contract and a thorough set of plans and specifications prior to construction; the best builders recommend that the homeowner commission an architect not only to produce these plans but also to administer the work. The price of the job should be established based on these plans, which is why as many details as possible should be determined before the renovation begins. That way, the homeowner has more assurance that all the goals and all the necessary construction work have been accounted for in the budget. Still, there are some details that are hard to determine precisely, such as paint colors and surface or cabinetry finishes, and often the architect and builder will allocate a certain amount of money for those remaining decisions.

The homeowner should also figure on a contingency sum that can pay for unanticipated problems, such as taking care of a rotted beam or an unsafe electrical connection that's discovered after the project gets under way. A contingency fee of ten to fifteen percent should be put aside by the homeowner for these sorts of unforeseen difficulties. Be sure that the specifications of the project can be achieved with the amount of money that's budgeted; the homeowner must have enough money to obtain good materials and good craftsmanship. A renovation that can be pursued only by cutting corners or choosing the least experienced contractor is not worth the effort.

The best minor change that a homeowner can make is to add built-ins. Window seats can provide great cozy corners and extra storage. Bookshelves and cubbyholes can be squeezed into unused corners and passageways.

Many houses come with decks that were not well conceived. Why live with an ugly deck that goes unused and needs to be maintained? Removing a deck is generally not complicated. It can be done in conjunction with the addition of new landscape features.

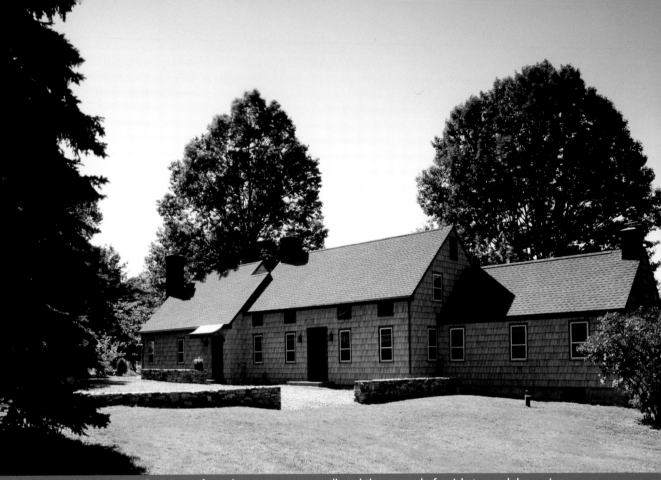

New rustic siding, a new front door, a new stone wall, and the removal of a rickety porch have given this previously makeshift home the appearance of a classic.

A Personal Touch

❝❝ In New York's Hudson Valley, friends and family helped Peggy search for a home that would be her personal getaway. She was looking for a place that had lots of charm and potential; it would also need to have a view of the river valley. She found a quirky home set on a rise overlooking the Hudson, with a prospect of the mountains beyond.

It was an odd house because it was built from salvaged parts of other homes, some dating back to the early nineteenth century. The center portion, with its wide front porch, and the south wing were the oldest pieces. After being moved there thirty years ago, the house had a wing grafted onto the north side, but neither the porch nor any good-sized windows in the original wings faced the view. Much later a poorly built trailer-like kitchen

116

If you find that it's impossible to achieve your wishes by making only minor adjustments to a house, you might consider a more far-reaching project, one that thoroughly refashions the house and changes its relationship to its surroundings. In considering this, keep in mind that a home's architectural character arises from both the exterior and the interior. Many parts of the house play a role in the creation of its character, such as the style of the doors and windows; the moldings where ceilings meet walls (or the absence of such moldings); and the materials with which the walls are surfaced (potentially as different from one another as rough plaster and refined wood paneling).

If your aim is to have a home in a particular style or in an amalgamation of styles (such as Craftsman with a

Step 15
Performing Total Transformations

Know the local property laws, your property's limitations, and your obligations before you close on a home.

modern influence or a Spanish bungalow with an Art Deco flair), you can pursue that by changing some of the parts, details, and materials of the house. A large renovation might change even the shape of the home. The roof might be raised or porches and other additions might be incorporated into the house. When the renovation is truly extensive, you'll end up with what is essentially a custom-built home. One virtue of a large-scale renovation is that it offers a great opportunity to give the house a new and better relationship to the landscape. Only a small proportion of the houses currently standing were built from plans tailored to their particular sites; most house plans treat the site as generic. A thorough renovation can adapt the house artfully so that it maximizes the potential of all the natural features of its site.

was added to the west, facing the water. As a result, the least attractive section of the house stood in the most desirable spot.

Peggy was not dissuaded by the house's poor design, for she had faith that she could get the quirky little house to take advantage of the view. Peggy made adjustments to the older parts of the house, adding windows and dormers. She removed the wide front porch that had gone unused because it faced the road rather than the vista. She moved the kitchen into the south wing and replaced the unattractive addition to the west with a new conservatory and screened porch.

These new indoor and outdoor rooms provide her with 180-degree views up and down the Hudson. Peggy's makeover retained the home's original charm on the side that faced the town road while adding her charisma through the new additions on the river side. This is house hunting at its best: recognizing that an attractively priced home with a couple of bad attributes and multiple good qualities can be a great buy.

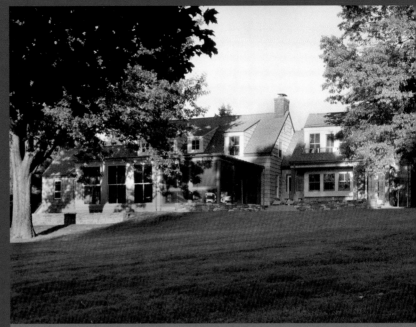

New porches, new dormers, a conservatory, and a big bay window on the kitchen improve the garden side of this home and provide an enviable view.

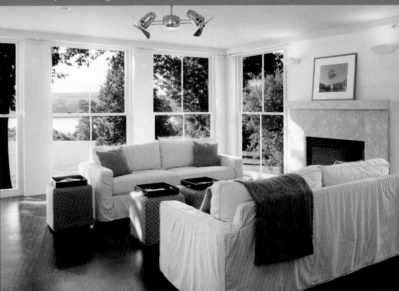

Two-over-two windows, a cork floor, and an elegant but understated fireplace make a new living room with abundant sunshine and views, yet a cozy feeling.

Not Just Bigger, but Better

Your adventure in good house hunting may reveal that the best option for creating the ideal place to live is transformation of the home you currently own. The transformation starts with hiring an architect to document the existing conditions; the architect creates floor plans and site plans representing the house as it is. These documents serve as a backdrop to the redesigning of the home. A small house can be enlarged many-fold. A large house can be made more intimate and easier to manage. In some cases, it will end up smaller than it started out.

A gut renovation offers little cost advantage over starting from scratch. Renovation may even exceed the cost of erecting a wholly new house. However, a full-blown renovation may be the best thing to do if the location or the land has amenities that you've come to love. A well-conceived renovation can make better use of the amenities, by improving both the house and the land. For example, many houses were built on steep slopes in such a way that the occupants could not use the downhill side of the property. A clever rearrangement of the interior and the addition of rooms or porches can give the occupants the ability to use much more of the land. That will make the entire property more valuable.

Many homes suffer from inefficient use of interior space. Conventional designs often include space-wasting grand entries, infrequently used formal dining rooms, and storage that's badly located or poorly organized. In a substantial renovation, you can rethink the entire interior, reshaping and reorganizing it to make it as useful as it can possibly be. The home can be rearranged into a layout that's ideal for the way the homeowners live. Unused spaces can be reshuffled to make spaces that are far more practical and comfortable. If the homeowners spend little time in their king-size master bedroom, why should its excess of space come at the expense of an extra bedroom or a room for hobbies or crafts? I think of a couple I met who were getting older and no longer liked climbing up the stairs to a second-floor bedroom. We reconfigured their house to put the master bedroom on the first floor, move a guest bedroom upstairs, and carve out space for a larger bath from an oversized entryway. Sometimes all that's needed to turn a dark and gloomy house into a bright and uplifting one is the opening up of the interior from end to end and the addition of a few windows in places where they can best catch the sun. Transformations like these produce homes that feel and act larger than their original designs allowed.

To save money on a major renovation, move out of the house while the work is being done. The expenses of the temporary housing will be more than offset by the efficiency of renovating an empty house rather than one that's partly occupied. You will save considerable time and money.

Caution: The cost of renovating an old home may be the same per square foot as building a brand-new house. An old house that once was structurally sound may end up almost worthless during a substantial renovation. If the house has a weak structure and it's disturbed, it will lose the strength it previously possessed. Most municipal building departments require the entire building be reinforced if more than fifty percent of it is remodeled.

❊ CONSTRUCTION ❊
MANAGE YOUR HOME IMPROVEMENT

Any type of home improvement, from repainting to adding a new wing, can be a frightening experience. Once the work begins, it can be hard to maintain a feeling of control. Regular meetings with all the professionals and contractors involved will go a long way toward settling nerves. One way for the homeowner to get the most out of the meetings is to be organized in your thoughts, listen and communicate carefully, and keep things professional. Here are some tips:

- Plan regularly scheduled meetings and save your concerns and questions until then. For larger renovations, every three weeks will keep you on top of the process and give everybody enough time to get things done between meetings.

- Insist that all questions to you come only at the meetings. All parties will plan and think ahead when they understand the ground rules.

- Always start on a positive note, such as with a friendly salutation and a compliment on things that are going well. (If nothing is going well, then a pleasant conversation on a general topic like the weather will cut the ice and ease the tension.)

- Review the discussions from prior meetings. Begin by reviewing answers, issues, or concerns raised in the previous meeting. If there are still unresolved issues, make a good faith effort to set a deadline for the solution.

- Review the progress of the project and take notes to be sure that you heard things correctly. Never be afraid to ask questions and take notes on the response. Every question helps the process, but it isn't necessary to get an immediate answer.

- Insist on a construction schedule that is regularly updated, and review it at each meeting.

- Insist that the budget and cost of a project be reviewed at each meeting.

- When there is a conflict, try not to argue. State your disagreement and then ask for a response. Take notes on the response but give all parties time to revisit the issue. If time is of the essence, then agree on a deadline for resolving the conflict.

- Never make a final decision at a meeting. All final decisions should be communicated in writing after the meeting.

- Review all the issues that have been discussed and reiterate what needs to be done by the next meeting.

- Check your notes and be sure that you covered all your issues and concerns.

- Never leave a meeting without scheduling the next one. This avoids cancellations.

Transformations

People who know very well that décors can be changed to reflect different tastes are often surprised to learn that the architecture of their home can be restyled as well. It's entirely possible, for instance, to convert a ranch-style house into a home in Craftsman style. Part of the Craftsman style is windows and doors that have a special grid division, with a large pane of glass in the center of smaller rectangular pieces of glass, and with trim capping the tops of the windows and doors and running past the trim that runs along their sides. Certain materials call to mind particular architectural styles. Earth-toned, rustic materials such as dark brown oak flooring with a heavy grain can give a room the look and feel of Craftsman style. An architect can renovate a home so that it incorporates details like those, suiting the homeowner's preferences and also adding character. Depending on its appropriateness, a home can have a split personality, as with a townhouse that has a brick and limestone nineteenth-century front and a brick and steel contemporary rear. A renovation of this sort can give the owners the best of both worlds. Family members with differing tastes can achieve contrasting visions of the dream home, with sections of the house each having independent character.

Enlarging a home by constructing additions is generally such a significant undertaking that this scale of project should be combined with whatever other changes the house might benefit from. If you're considering a remodeling, think about whether there is anything else you plan to do to the house in the next five to seven years; if there is, do everything at one time. Financially, I know, this is easier said than done. But extensive projects typically take two years or longer to finish and are disruptive. It's heartbreaking to think of going through another construction project soon after the first one has been completed. Doing as large a project as possible is less stressful and is more cost-effective, since contractors and subcontractors can accomplish more for the money when they don't have to return, set up operations, and leave again. It's better to spend more time planning and to hold out for as long as you can so that you can afford the best renovation possible. Extending the time devoted to planning and bidding a job can also produce cost savings. Most of the expense of a substantial renovation is labor, not materials. Contractors set the labor costs, and homeowners who are in a hurry to finish a project often have a hard time getting a good choice of competitive bids.

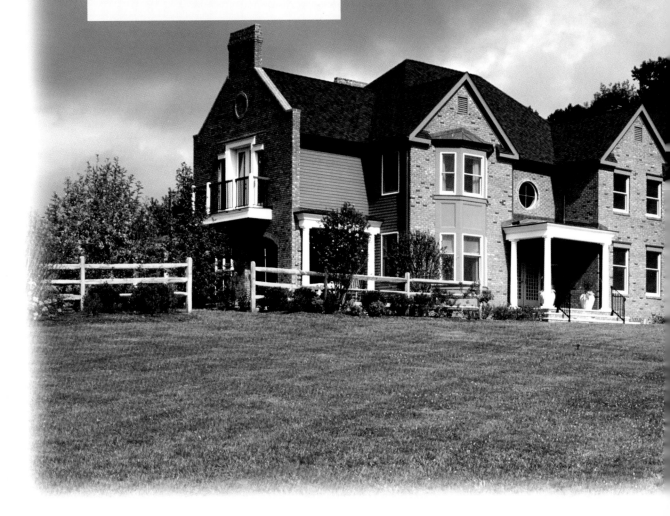

ADDRESSING THE TRICKY STUFF

Even after twenty years of helping people achieve what they want in a home, I still get surprised by some of the events that occur in the course of good house hunting and dream home planning. Designing, building, and renovating are complicated tasks in themselves. They become even more complex when the widely varying specifics of each individual, each property, and the particular city or town are added into the mix. Municipal rules and regulations may apply differently to one house than to other houses down the street or even to the house next door. An improvement to an apartment in a condo or co-op building may be subject to review not only by the building's management but also by a slew of other private and public organizations.

Creation of a dream home does require a lot of time and preparation. Each project needs a team of people to help bring it about. Once the idea of making a home improvement has taken hold, a team of people who will bring it to fruition has to be found and assembled. The endeavor does not always go smoothly. As with any venture that involves money, it's best to prepare for every possibility, to have good documentation, and to have sound contracts with all of the participating parties. The uncertainties compound the stress of making changes to a home. The good news is that improving the comfort, quality, and health of one's home is almost always worth the effort. The secret to success is good preparation, being attentive and decisive, and having lots and lots of patience.

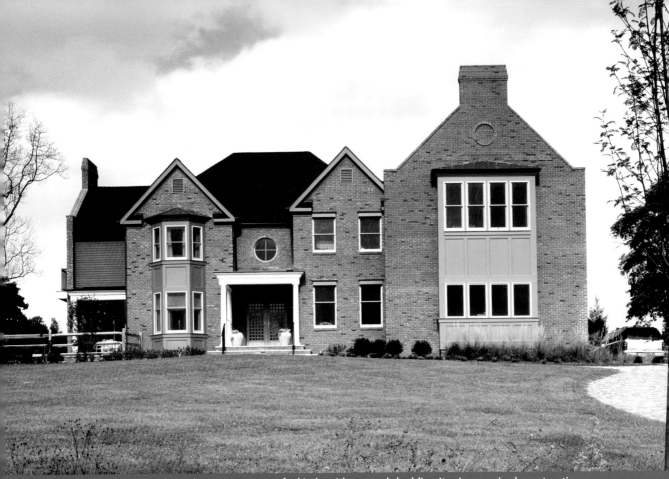

Changing an ordinary home into a one-of-a-kind residence and doubling its size required great patience and fortitude from the owners. Big results demand big resources.

Room to Grow

🌷🌷 Jim and Jackie had three little children—one girl and two boys—and a fourth was on the way when we met. They had bought a piece of land in a new subdivision of build-to-order homes in the New Jersey countryside. Their plot was surrounded by horse farms, had good schools nearby, and was an easy commute to Jim's office, but after a few years, the house they had built there was insufficient for the needs of their growing family. They had also become disenchanted with its standardized layout and appearance. "I thought I was building a unique custom home," Jackie said, "but I realized that it was a standard house design, and the only real choice I was given was the color of the kitchen counters and the bathroom tiles."

Jim and Jackie debated whether to renovate the house or sell it and start over. Jackie

wanted a larger better-built home that had one-of-a-kind appeal. Both preferred remodeling the home they already had, but they were afraid that doing so would compromise their goals and overinvest on the property. Renovation can

Constructing, renovating, or even decorating a home can be stressful. The home is a sanctuary, and we rely on its stability to feel secure. I've noticed when even the slightest thing is out of place and I cannot determine how it got that way, the sensation is quite irksome. Creating a dream home requires change, and you have to reconcile yourself to the fact that it's a disruptive process, even when the adjustments and improvements are seemingly minor. It's not helpful to deny your natural reactions or imagine they can be avoided. They can, however, be managed.

Relish the excitement of the planning phase. Anticipate the displeasure of discovering the cost of the work. Allow yourself to get emotional when faced with difficulties. It doesn't do much good to deny your instincts. Nonetheless,

Step 16

Weathering the Storm of Construction Work

Building, renovating, or repairing a home can be hard. Stay in control with realistic expectations, a steady focus, and a bright outlook.

you should quickly try to redirect that energy. Use it to help you make better decisions. From the very beginning, practice patience; construction work and home improvements always take longer than you would like. Trust that you can remain in control of the process, and know that you will reap the benefits by exercising careful attention and decisiveness. Most importantly, remember that when you're working toward a dream, it's not necessary to be happy every step of the way. What matters is that when you reach the end, you'll have a satisfying home.

Be Realistic

The most disheartening experiences occur when people cling to illusions about how much money or how much time a project will require. Unrealistic beliefs cause far more

be more difficult and time-consuming than new construction because it entails salvaging and improving the original structure. Despite those cautionary factors, we concluded that Jim and Jackie should transform their existing home because when they looked at available properties, they ended up impressed with where they already lived. "Once we realized we needed more space," said Jim, "we started to look again at nearby land and neighborhoods, and nothing compared to what we had."

The house hunting revealed that Jim and Jackie had made two good decisions. First, they had bought property based on its intrinsic strengths: its bucolic setting, the community that it was a part of, and its convenient location. It was a highly desirable corner lot. Second, they had erected a house more modest than its neighbors. Its construction cost was relatively small compared to its current value. Because they had bought wisely, they had the resources to make improvements that would add space and infuse the home with their personal touch.

Their discovery of a location that remained endearing with the passage of time and that allowed room for creating the dream home over the years is an example of good house hunting. Today, after renovating and expanding, they continue to live there—in the home of their dreams.

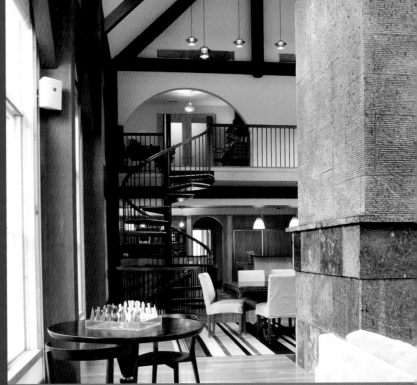

A double-height family room provides the drama that the original home lacked.

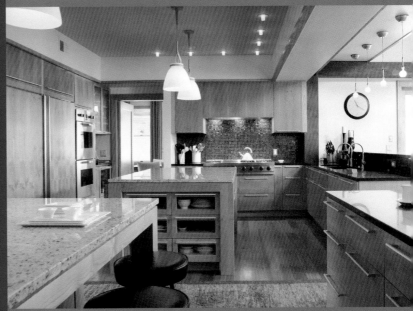

The kitchen tripled in size, providing two separate cooking zones, two islands, and two peninsulas.

disappointment than is necessary. So you should never rely on information offered by neighbors, friends, or family. Each person's experience is unique, and memories are faulty. You can't rely on what a friend says a home improvement should cost.

For straightforward projects, such as refinishing or replacing parts of your home, you can go to suppliers and distributors to learn the cost of materials such as paint, wall and floor coverings, stone and ceramic tiles, and the like. You can then compare those figures with the estimates you receive from prospective contractors. With good specifications, a contractor ought to be able to give you a solid estimate of the time required for carrying out your project. The contractor should be willing to commit to the time frame he suggests (with some room built in for possible miscalculations or unanticipated problems). Never take one contractor's word, no matter how trustworthy he may be. And if a contractor's estimate looks attractive but is wildly different from all the others, be suspicious; it's probably too good to be true. A second and a third opinion will improve your understanding. For example, if a contractor has difficulty explaining why the cost of replacing a few windows may be higher or lower depending on how much flashing work is required, another contractor may explain things in a different, clearer way.

For larger jobs, it's best to get advice and assistance from an architect or interior designer. They can advise you on the potential costs and the likely time frame of your project. Keep in mind that you're likely to get the most straightforward information if you ask for conservative estimates. Even the best advice can be off, however. You should be prepared for the fact that miscalculations of time and cost are common, which is why you should ask for a "contingency"—the term that designers and contractors use when referring to planning for unforeseen costs or delays. It may be silly to call such occurrences contingencies, since it's impossible for a home improvement project to have no human errors, but that's the word that everyone accepts. Contingencies come in two forms:

Cost contingencies. As previously mentioned, even the smallest projects will face a few miscalculations and unanticipated changes, resulting in additional costs. A safe assumption is that cost contingencies will amount to at least fifteen to twenty percent.

USING AIA CONTRACTS

Life is filled with mishaps, misfortunes, and outright catastrophes. Consequently, anyone embarking on a home improvement or construction project should become familiar with contracts, which offer some protection when things go wrong. Ideally, everyone involved in the project is personally committed to completing the job in the most effective manner possible. As a practical matter, a well-defined contract is a necessity.

On any project requiring a substantial amount of cash or a bank loan, I recommend that all parties use the appropriate preprinted contract from the American Institute of Architects (www.aia.org), which is available from the local AIA chapter. The contract includes documentation that defines what is required of all the parties. It stipulates, for example, that as an owner, you are not obligated to know what is considered good construction practice—that's the contractor's responsibility. So if you request that something be done a certain way, the contractor must ensure that things are built properly.

❧ WEATHERING CONSTRUCTION ❧

THINK CAREFULLY, PLAN LONG-TERM

DO

ROUTINE MAINTENANCE

Create a budget for regular maintenance and consider tending to one issue per year. A suggested budget for maintenance is one percent of the house's purchase price per year.

ROUTINE HOME IMPROVEMENTS

Set a routine home-improvement budget of another one to two percent per year. Save and plan ahead to make a big improvement once every five to seven years.

SUBSTANTIAL RENOVATIONS AND NEW CONSTRUCTION

Create your home as it will work best for you. Make the most of your landscape, your taste, and your aspirations.

Invest in professional help. For interiors, hire an interior designer; for construction, hire a residential architect.

Insist on a thorough contract with a clear budget and time frame. Use a pre-printed AIA contract or seek advice from an attorney on the terms of an alternate version. Be sure that the renovation or new construction work is well documented and is attached to the contract.

PEACE OF MIND

Consider doing more with less by maintaining a smaller but better home, building a smaller addition using higher-quality materials, setting a smaller construction budget that allows spending for professional help.

DON'T

Don't skimp on or postpone maintenance projects. This will only lead to more costly repairs down the road. One year paint the house, another year fix the gutters, and so on.

Don't bother with small home improvement projects done on the cheap. Wait till good-quality materials, good workmanship, and professional help can be afforded.

Never worry about creating a home that will not be good for resale. As long as the renovation or the construction is of a high quality and suited to its location, it will hold its value.

Never try to execute a substantial renovation or new construction without good representation and good documentation. It is better to realize a smaller project with professional help than risk your investment without such expertise.

Never agree to an open-ended contract. Every project should have a contract that states either a budget or a fixed price. Every contract should have an attached schedule of completion and should have both incentives and penalties for adhering to the schedule.

Don't pretend a home or a home improvement will cost less than you've been advised or your research tells you. This will lead to heartache or blunders. Owning or creating a home that you cannot easily afford or properly maintain will not only lead to dissatisfaction but may also put your initial investment at risk.

Time contingencies. Anticipating miscalculations and unanticipated delays, you should be especially generous in figuring time contingencies. I suggest adding thirty to forty percent to the estimated schedule.

The contractor should be held financially liable if he or she goes beyond that contingency. To minimize stress, the family may want to anticipate even greater delays. For example, if a family opts to move out of the home for six months while it is being improved, it's a good idea to have a backup plan in case you're prevented from returning for an additional three to six months. Planning for contingencies will not jinx the project; it will merely give you preparedness for bumps in the road.

Taking Control with a Positive Attitude

The attitude to nurture when creating a dream home is pretty much the same attitude you need when raising a kitten or a puppy—a feeling that there will be difficulties and disruptions, but they come with the territory and are more than offset by the rewards. During a home improvement project, a positive attitude can go a long way toward managing your emotions. Just putting on a smile is a trick I always use when going to a house in mid-construction.

People are more likely to believe that you can be decisive and reasonable if you appear confident about the results. The more responsibility you accept, the less anxiety and the more satisfaction you will find in the end. This is critical, for when problems arise, you don't want anyone to harbor fear about coming to you early on with all the information at hand. Hearing about a miscalculation or an unresolved issue as soon as possible allows the person in charge to make the best choices. For example, if a contractor realizes he has ordered the wrong window but is afraid to admit it, the problem is that much harder to fix. Maybe the window the contractor ordered was not so far off from the one you had in mind, but the contractor, fearing how you'll respond to the error, might assume you would reject it and send it back. That could cause unnecessary delays and added expense, and it may be unnecessary, because he didn't try to find out whether the error was really detrimental. Finally, remember that professionals work harder to make things right, and feel more obligated to the clients, if the clients listen carefully, stay coolheaded, and appreciate things that have gone well.

When things have gone wrong, avoid turning negative. Nothing is gained by seeing yourself as a victim. Everyone's stress levels benefit if people remain optimistic about what's to come. Communication is more fluid and honest when there is a positive atmosphere.

No matter what anyone tells you, never proceed with a home improvement without a thorough contract. Avoid losing control. The American Institute of Architects has preprinted contracts available for every type of residential construction project.

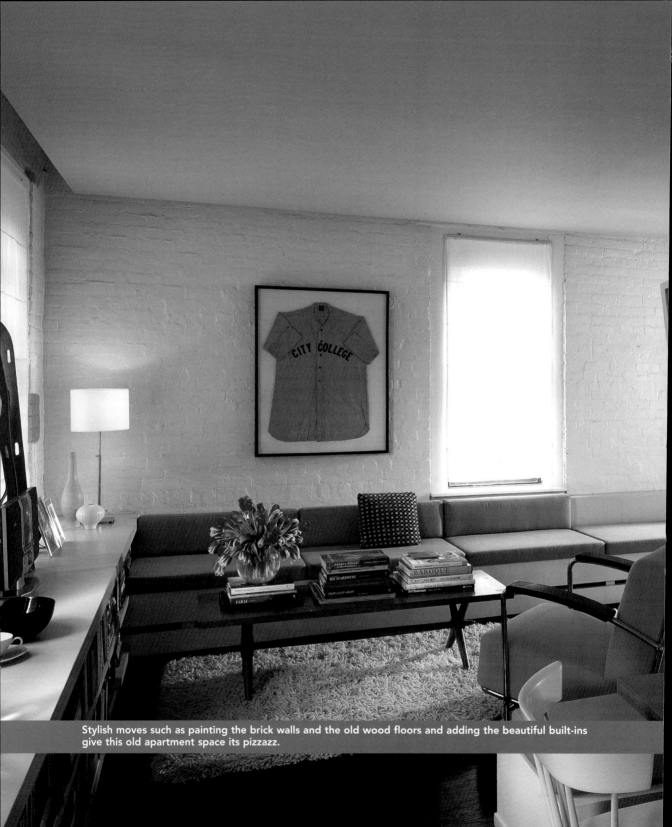

Stylish moves such as painting the brick walls and the old wood floors and adding the beautiful built-ins give this old apartment space its pizzazz.

The hardest part of achieving the dream home is knowing when to stop. A home is a hand-made creation that gets better as it is adapted to its owners and its location. But it does not need to be flawless to be wonderful, nor does it need to be ostentatious to be impressive. A home, in my judgment, should be more like grandma's quilt than like a store-bought blanket. The most beautiful homes feel unpretentious.

This is not to say that a dream home should avoid striving for high quality. On the contrary, a house becomes a dream home in part through the owner's quest for designing and building well. But it's essential to recognize that a well-crafted home possesses humility—which it obtains through a bit of quirkiness, slight imperfections, or signs of age. A home with a degree of humility is more comfortable to live in. Certainly

Step 17

Knowing "When to Leave Well Enough Alone"

Realize that a total makeover can be expensive but the results can be even better than starting from scratch.

it's less daunting to have this kind of home as your objective, rather than trying to create and maintain a home that's utterly perfect. This is why rustic retreats and country homes appeal to so many people; their imperfections—often the result of wear and tear—add a pleasing character, in the same way that signs of years of use add allure to an antique.

To nurture and appreciate unpretentiousness, the home-owners must tolerate oddities in the design or even minor aesthetic faults in the construction. In certain cultures, such slight irregularities are believed to give a house its soul, by avoiding offending the gods or by avoiding any attempt to be superior to them. My view is that quirks, irregularities, and minor flaws contribute to peace of mind, relieving the stress that often comes with trying to create the ideal home. The humility embodied in a good home reminds the inhabitants

that the house should be fully enjoyed. It should not be so precious that people feel that their own presence is a problem.

Homes That Look Lived In

A dream home ought to have a comfortable interior. The trick is to create one that is stylish and well finished, yet relaxed. Spaces should be organized but not uptight; rooms should be striking, but should not look like a hotel lobby. It's a question of balance, a matter of improving the interior to give a good impression and add quality but without creating a space that's overwhelming or garish. The route to a stylish, well-appointed, yet relaxed home is not hard to follow if you're willing to do more with less. The "doing more with less" approach will help give each room an appearance that doesn't seem cluttered or fussy. This approach will also allow you to accomplish more of your dreams within a set budget.

Start by appreciating those parts of the home that may not be ideal but that are good enough just as they are—things that are built and that function well. Not every detail of a home must be artistic. Not every useful item must be hidden in a cabinet or finished in stainless steel or made to look like an antique. Not every worn surface must be replaced. The comfort of the interior will suffer if the rooms become too precious or lavish. In that kind of atmosphere, whenever anything is out of place or shows evidence of wear, the aesthetic effect is spoiled. My experience is that people who have high standards for their homes devote too much time and effort to hiding things like televisions and radiators. It's better to be a little relaxed in your outlook. If a room is organized, well crafted, and fittingly maintained, it can accommodate practical items like stereo speakers, books, and appliances out in the open without losing its appeal.

The key lies in developing a sense of how many decorative features will be enough to generate the look and feel the homeowners want. If there are too many features, the effect is likely to be garish. One set of clients told me they wanted a "man-eating fireplace." They cut out magazine pictures of giant fireplaces in the lobbies of hotels and in the receiving rooms of castles, thinking that a massive feature of this sort would make their home impressive. I persuaded them that a slightly taller than usual fireplace with a robust mantle was all they needed; it would give their living room the look and feel that they were after. If the fireplace were enormous, it would

The route to a stylish, well-appointed, yet relaxed home is not hard to follow if you're willing to do more with less.

make the room look silly. It would also be uncomfortable to use. The moral: Avoid overkill. There is no need for trim at every corner of a room or for installing fancy moldings in the quest for an elegant sensation; it's a better value to have fewer details but in a high quality.

Rooms, I believe, are more emotionally effective when they're eclectic. They gain appeal when they combine architectural details and objects that inspire admiration, regardless of their particular style. Any style, from country to modern to classical, is likely to achieve a more heartfelt and relaxed appearance when it's not overdone, when it has a touch of simplicity and originality. This may mean retaining an existing, traditional element in the house when introducing a contemporary design, and vice versa. Allowing something personal, even if it's slightly out of sync with the desired aesthetic, tends to make the home feel more genuine.

Homes That Age Well

Interiors, exteriors, and landscapes all seem more relaxed and enduring, and are easier to maintain, when they're relatively down-to-earth. So consider using natural materials in all areas of the home, inside and out. Natural materials, properly installed, age well. Even if their finish fades a bit from the sun or darkens from moisture, they remain attractive. Homeowners should think twice before doing things like replacing old wooden fences with shiny new vinyl versions. Blemishes often bring out the character of materials by highlighting their natural textures, such as the grain of wood or the veining of stone. Newly built houses can acquire this kind of character by adding porches, terraces, and other landscape features.

Have you ever noticed how old villages or seaside neighborhoods somehow look more charming, with less effort, than newly built communities do? The old places have a certain mellowness that develops with age. I love the look and feel of a town square surrounded by fenced gardens, stone terraces, and old wooden porches. The beauty and the experience of the place are enhanced by the signs of weather and age. Just like those venerable town squares, comfortable homes are not static; they're dynamic. They reflect changes that occur with the passage of time and the whims of different owners. Anyone aiming to make the most of a house should use the element of time to full advantage.

Usually it's a waste of effort to try to hide or disguise the convenient and useful things that a family uses every day. Even people who generally prefer not having things out in the open should allow some rooms to have things on shelves, counters, or hooks where they're easy to find and use.

There are two benefits from training yourself to be comfortable with slight imperfections that do not detract from the overall excellence of a home. First, you save money. Money spent trying to take a home from high quality all the way to perfection usually does not improve the home all that much, so resources are wasted. Second, becoming comfortable with slight imperfections brings a sense of harmony. Unnecessary dissatisfaction diminishes the pleasure of owning a home. People are better off pursuing their essential needs and heartfelt wishes and not seeking unattainable perfection.

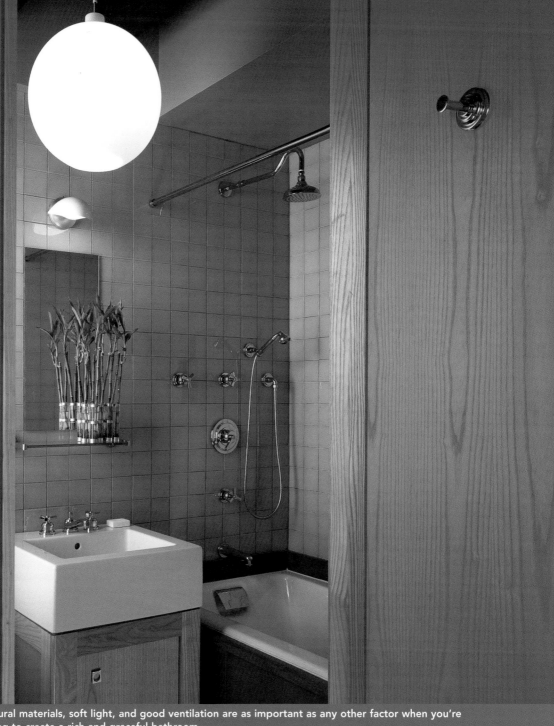

Natural materials, soft light, and good ventilation are as important as any other factor when you're trying to create a rich and graceful bathroom.

Appreciating a healthy environment is as easy as discovering that the scent of fresh air does not require gadgets for filtering or artificial deodorizers to mask smells. Healthy homes are filled with fresh air and daylight. Homes built from renewable materials, such as wood from a managed forest, can also be healthy for our environment by minimizing the depletion of limited resources. Houses designed and built to be sensitive to the quality of the environment, indoors and out, are often referred to as green or sustainable. Their creation does require research and the expertise of professionals.

The good news is that more and more designers and contractors are becoming familiar with techniques for creating healthy homes. Local chapters of the American Institute of Architects and the United States Green Building Council can

Step 18
Recognizing Healthy Environments

A healthy home is a happy home; beware of the hazards of indoor air pollution and unsafe conditions.

help people find such professionals. The other good news is that there are simple things that can be done, either all at once or over a period of time, to improve the health of a home. Today all-natural choices exist for nearly every material that goes into the creation and maintenance of a home. Magazines and books offer well-researched advice on healthy ways of building, renovating, remodeling, and cleaning the places where we sleep, eat, and raise families.

The ingredients for a healthy home read like a list of materials the early settlers used on and in their homes: wood, flax, cotton, wool, vegetable dyes, milk paints, stone, and iron. Leading manufacturers in every sector of today's building industry provide alternative products made from ingredients such as these because, of course, natural materials have proven to be healthier than modern synthetics. Did you ever

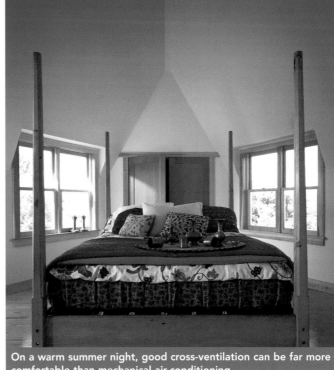

On a warm summer night, good cross-ventilation can be far more comfortable than mechanical air-conditioning.

The dream home is a home that not only looks good but also benefits the health of you and your family.

wonder why you have trouble breathing at night in your beautiful new master bedroom or why you always seem to get a headache while reading in your recently renovated library? It might be because of the kind of wall or floor coverings that was used, or the paint, or the glues or finishes used in manufacturing your new furniture. The dream home is a home that not only looks good but also benefits the health of you and your family. All it takes is a little research.

Indoor Air Pollution

The building industry is discovering that indoor air pollution in newly built homes is a far more serious problem for the majority of homeowners than is polluted outdoor air. The reason is simple: Many household products and materials release gases that are irritating or, even worse, toxic. Some glues, paints, and polyurethanes—used on floors, walls, and ceilings—release fumes when they're applied and continue emitting them for weeks or months afterward. Certain floor coverings, such as synthetic carpets and vinyl flooring, deteriorate over time, releasing tiny particles into the air—a process referred to as off-gassing, which can be harmful to human

health. During construction, many building materials that pose potential hazards, such as fiberglass insulation, are installed. Particles of these materials can linger inside long after the home is complete. Combine the particles, the emissions, and the fact that new houses are increasingly air-tight—trapping these pollutants inside the home—and there's reason for concern.

Most newly built homes are so well insulated and so extensively air-conditioned that they rarely air out. Every time a cleaning product is used from a spray bottle, it puts fumes in the air. Every time a new carpet is installed, the walls are repainted, or new furniture is brought in, additional fumes enter the household air supply. Think of the smell of a new car. It's actually the odor from the synthetic fibers used to make the seats, the dashboard, and the carpeting. We all love that scent because it reminds us of the joy of owning a new car, but in fact it is the smell of chemicals and petroleum-based synthetic materials. These fumes are particularly strong when the products are new. Although new cars quickly air out, new homes do not, because people don't know that they need to ventilate them. All liquid products that use chemical compounds, such as waterproof glues, dry-cleaning fluids, and most paints and polyurethanes, release harmful gases. When using these to create your dream home, try to minimize your exposure by airing out the home frequently. Simply allow the interior to air out for a few weeks by opening windows before the home is heated or air-conditioned. A worthy investment is upgrading your HVAC system to incorporate an air exchanger, which will bring fresh air into the house without diminishing the efficiency of your heating and cooling systems.

Alternative Materials

A safer method of achieving a healthy home would be to avoid these gases by using products certified as healthier, such as low-VOC (volatile organic compound) paints and natural cleaners and glues. Replace as many synthetic materials as possible with natural materials. For new construction or renovation, there are alternative building materials, which cost about twenty percent more but are non-toxic and better for the environment, such as all-cotton insulation in lieu of fiberglass, natural linoleum instead of vinyl tile, cedar siding rather than vinyl siding, and wood roofing shingles rather than fiberglass. Using

alternative materials not only reduces the potential harm to the occupants. It also is better for the installer—who may be the homeowner, especially when a house's finishes and maintenance are involved. It is remarkable how different a project site can be when alternative, low-toxicity materials are used. The site smells different without the heavy fumes. The most challenging aspect of using alternative materials, other than their cost, is finding products that are tried and true. Many new products are available, but the companies that produce them are often just starting out. It is a safer bet to look for materials that are good for the environment and are produced by companies with a long history of manufacturing building materials. Having said that, I would note that it is important to do comparative research no matter who the supplier is. Claims that a product is healthier need to be backed up by comparative statistics. The best approach is to work as a team with the suppliers, professionals, and contractors, exploring the options, until a consensus emerges as to which products have the most to offer.

Fighting Mold and Excess Moisture

Everyone is familiar with the unpleasant smell of a musty basement or attic. That smell is usually the scent that comes from mold—bacteria recognized by the green, blue, or brown stains that show up on basement or garage walls, bathroom tiles, and ceilings that have had water damage. Out-of-doors, mold is what gives natural materials their patina; it can add character and charm to their appearance. Indoors, mold is unattractive and unhealthy, and it needs to be attended to. Moisture and humidity encourage mold, which can easily be cleaned off of non-porous materials such as ceramic tiles. Mold is more difficult to remove from porous surfaces such as wall and ceiling boards. It can go undetected in areas that are hidden, such as the back surfaces of walls, ceilings, and floors. The most practical thing to do about mold is regularly remove what you can and minimize moisture in the house. This means installing dehumidifiers, fixing leaks, and channeling water away from the home. Unless an interior space, like a basement or a particularly damp room, can be kept dry and mold-free, it's best to minimize use of that space and keep it aired out. Common sense helps. If you train yourself to be aware of such smells, you'll at least know when there's a problem. If it doesn't smell fresh, it may not be a healthy home.

The most challenging aspect of using alternative materials, other than their cost, is finding products that are tried and true.

HEALTHY HOME

EDUCATE YOURSELF ON WHAT TO LOOK FOR

GOOD MOVES

- Well-placed deciduous trees reduce air pollution, provide shade in the summer, yet allow warm sun to enter in the winter.

- Low-maintenance indigenous plants and shrubs surrounding the home are attractive and great for the environment.

- Properly managing rain runoff from the house and from hard surfaces (patios and driveways) lets water percolate into nearby ground to recharge the water table and minimize overflow of community sewer systems.

- Natural or sustainable materials, such as wood and brick, and recycled roofing materials are better for the environment, more beautiful, and healthier to be around, and they are of the highest quality.

- Views of sky and a combination of sun and shade provide the ideal vistas from windows, and pleasant, soothing interiors.

- Passive solar features are energy savers. They include deep overhangs, windows facing south, solid walls facing north, and materials that can absorb the sun's warmth.

- Wood floors come from a renewable resource, and they minimize trapped dirt and bacteria.

- Low-VOC paints and natural-based floor finishes are healthy ways to decorate and protect surfaces.

- Well-insulated homes lower energy bills and minimize the use of fossil fuels, which are not renewable and pollute our environment.

CONCERNS

- Absence of landscape amenities can be a sign of poor soil, careless development, or industrial pollution.

- Decorative plants and shrubs and large areas of perfect lawns are often maintained with pesticides and chemicals and may waste water through the effort to keep them green.

- Poorly managed rain runoff is worrisome, especially if it appears that water runs down the house, causing wear and tear, rot, and damp conditions.

- Vinyl siding, Exterior Insulation and Finish Systems (EIFS), and single-tab asphalt shingles are nonrecyclable synthetics that use non-renewable petroleum-based products. This type of shingle is cheap and doesn't last long.

- Harsh or minimal sun throughout the interior can make homes dependent on energy-consuming mechanical systems for comfort.

- Poor ventilation traps bacteria and pollution indoors. Stuffy, smelly, and dirty homes are often unhealthy. The American Lung Association has a healthy home specification guide at www.healthhouse.org.

- Glue and off-gassing pose a big concern when floors are covered in nylon carpets, vinyl tiles, and sheet vinyl.

- Lead paint is a danger to children and adults and is very difficult to remove successfully.

- Poorly maintained HVAC systems waste energy, trap bacteria, and add unnecessary noise to the indoor and outdoor environment.

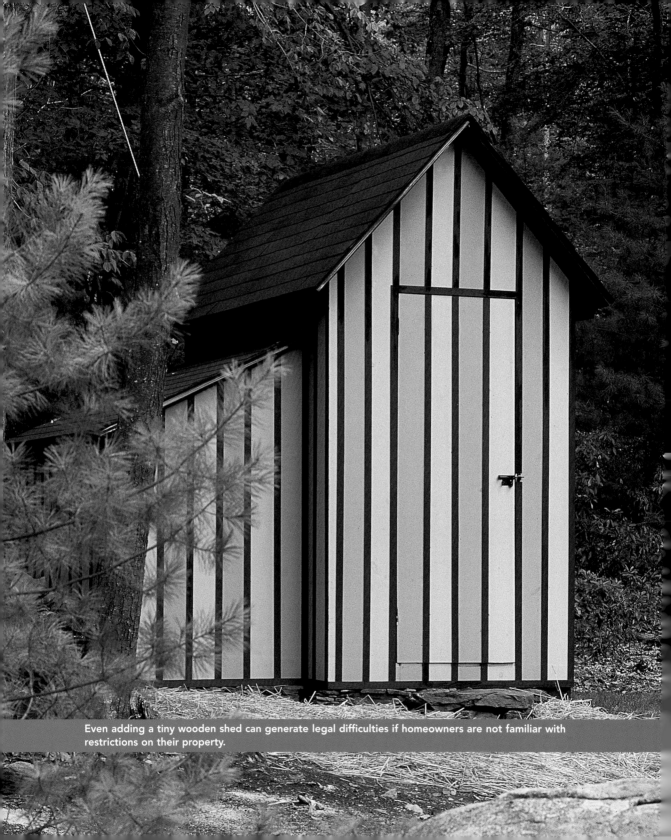

Even adding a tiny wooden shed can generate legal difficulties if homeowners are not familiar with restrictions on their property.

One of the rewards of good house hunting is the pride and freedom of homeownership. People who have chafed under the restrictions of apartment life eagerly anticipate the freedom to create a place exactly to their own liking. I hate to be the one to spoil that sense of complete control, but the truth is, all homes have rules and regulations attached. People can achieve their dream home only if they thoroughly understand the restrictions governing their property.

Condominiums, co-ops, attached houses, and freestanding homes all come with documentation that identifies what the owner actually owns. A family that owns a house occupying part of a block in a town will have a deed describing the property and defining where the property begins and ends. The deed may have legal restrictions written in it—

Step 19

Understanding What the Government Has to Say

Learn the rules and restrictions imposed by the government and other authorities.

allowing the local government to run utilities at the edge of the property, for example. These are called deed restrictions. They are often put in place over the years as one owner or another consents to them, and the courts can enforce them.

In addition, the municipal or county government may enact restrictions such as limiting the height of the tallest part of the house or prohibiting the use of a wood-burning stove. The state or federal government may restrict certain changes to the land—preventing anyone from filling in a swampy area that is considered a protected habitat, for instance. "I know one person who bought an approved residential lot and, when he applied for a building permit, was told the lot was all wetlands (under state law) and not buildable," says Joel Russell, a planning consultant in Northampton, Massachusetts. "It took him about two years,

For co-ops and condos, the rules of the building may dictate the materials and methods used in renovations, so everyone involved should understand them as early as possible. For example, the rules may not allow a floor to be covered entirely with hard surfaces, because those could transmit noise to lower apartments. A plumber may not be allowed to install a food disposal in a kitchen because of the condition of the building's septic systems. The more you know about the rules and regulations, the less likely you are to waste money and time on ideas that aren't feasible.

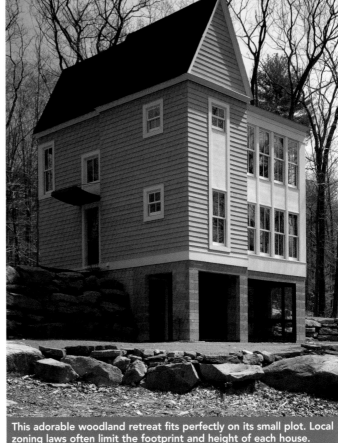

This adorable woodland retreat fits perfectly on its small plot. Local zoning laws often limit the footprint and height of each house.

using lawyers and consultants, to prove to the local conservation commission that there was enough dry land to build a home." Also, neighbors may have formed a community association with its own set of legal restrictions, such as limiting the kinds of outdoor lighting that are permissible. It's essential to find out which rules of the association would affect your plans. With a little imagination, most of the aspirations a homeowner has can be accomplished while complying with the rules and regulations. Pursuing wishes that conflict with the restrictions, however, can be a nightmare.

Building Department

Homes of all kinds come under the jurisdiction of the local building department. The job of the building department is to know all the rules and regulations that federal, state, and local authorities exercise over properties in its jurisdiction. Building officials may not be able to tell you every rule off the

tops of their heads, but they can point you in the right direction so that you'll know which ones apply to your property. Typically the first thing you'll want to ask is: When does a home improvement require the municipality's approval? As a rule of thumb, anything more far-reaching than decorative work must win approval from the building department. This isn't necessarily bad. The building department and its regulations are there to protect your well-being and the well-being of your neighbors, the community, and the environment. The department cannot tell you what restrictions are placed on your deed, but it can assist with enforcement by refusing to accept applications for permission to build if the department becomes aware that the work would violate a deed restriction.

The same holds true for rules and regulations established by a community association or a block association. Clients of mine purchased a piece of land from a developer without learning that all the land in the area—their own and their neighbors'—was regulated by a community association. The clients submitted an application for a building project to the local building department, received approval, and started work, only to be told that they should have obtained permission from the association board, not just from the municipality. The building department ordered a stop to the work after being notified that the association had not approved the project.

When reviewing an application for a construction project, the building department will check on whether the project complies with local zoning regulations. Not all towns have zoning rules, but the great majority do. Their purpose is to protect property owners from harmful and disruptive development in their vicinity. One kind of zoning provision prevents a homeowner from replacing his house with a gas station or a porn shop. These are the zoning laws that regulate use, and they can extend to much less egregious uses, such as a pottery studio or a boat repair shop you'd like to set up in your garage. Another zoning provision stipulates where a home or an addition is allowed to be built on various properties. These restrictions are usually described as setback requirements. Ordinarily, nothing can be built outside of the setback lines, which specify a distance from the front of the lot and usually from the sides and rear of the lot as well. The town or city could change its setbacks requirements at any time, so the property you buy could be assigned a larger buildable area or a smaller buildable area than when you purchased it.

SEEKING AN EXCEPTION TO THE RULE

Building departments or co-op and condo boards do not strive to impede homeowners from improving their property. But it is not possible to make rules that anticipate every possible request. So if homeowners believe the improvement they seek to make will not be detrimental, they can ask the governing agencies to grant an exception.

For example, if a property has an unusual shape and the homeowners want to add a porch, but it cannot fit entirely within the setback, they might request a variance, arguing that the porch would be in line with the other porches on the block and would not detract from the block's appearance.

Within local government there is a board that reviews such appeals. Generally, the homeowners are required to notify the neighbors about the request for the variance. There may then be a public meeting to discuss the merits of the request. An exception is unlikely to be approved if the rule protects the health and safety of the occupants and neighbors.

RULES AND RESTRICTIONS
LEARN EARLY ON WHAT APPLIES TO YOUR PROPERTY

When buying a house or land, have a lawyer walk you through the property deed. To understand what you are purchasing and as useful reminders for the future, take notes as you understand the issues that involve possible restrictions on the property. For example, some property deeds have "rights-of-way," which means that other parties have the right to use part of your land. A utility right-of-way is common; a neighbor may have the right to run a power line through your land. Other deeds have covenants added to them. The covenant is a sort of promise or pledge that the new owners take on. For example, a covenant might be added that prohibits owners now or in the future from removing an old windmill or monument. Add notes about all government rules and restrictions that might affect future improvements or expansions. These should be kept and updated.

SAMPLE PROPERTY DEEDS

Right-of-way

Our neighbors have a right-of-way at the southern end of our land. This allows them to put in a driveway if they ever want to subdivide their property and they need access to the part of the land that borders our property.

Covenant for Old Maple Tree

The former owner has added a covenant preventing any future owner from cutting down the old maple tree in the middle of the yard. We are required to maintain it to the best of our ability.

EXAMPLES OF GOVERNMENT RULES

Community Association

We are not allowed to make changes to the curb side of the house, including the paint color, without the approval of the Community Association.

Zoning

Our house is built as close to our western property line as allowed by the town zoning laws. If we want to add a garage there, we will need a variance. According to our architect, we can only increase the size of the house by another twenty percent; otherwise we will exceed the allowable "footprint" (the outline of the house's outer walls).

Architectural Review Board

If we add on, we will need approval from the town's Architectural Review Board. According to our architect, that means the addition will have to be of a similar Colonial style if it is to pass easily.

Environmental Rules

When we add a new garage, the driveway will be allowed to be only so large, and it will have to be installed so that not all the rain water runs into the street. A manager at the garden nursery said that she knows a landscape designer who can design a way to take the rain water and channel it into a new "wet" garden that will satisfy this requirement.

After receiving an application, the building department will also check on the building codes. These codes regulate the way things are built, often including materials, electrical systems, handrails, and other matters. Building codes focus primarily on protecting the health and safety of the occupants and the neighbors.

Condo and Co-op Rules

Like houses, apartments are subject to the rules of the building department. Often the laws governing multi-family residences are more stringent than those affecting detached dwellings. For example, in some municipalities, individually owned apartments are required to meet the standards of the federal Americans with Disabilities Act regardless of whether the owners or residents are disabled. This could mean that when renovating a bathroom in a condo unit, you would need to build it so that it could easily be used by a future owner in a wheelchair. The government procedure is the same for condo and co-op units as for freestanding houses in that the improvement needs to be reviewed by the building department. The architect or contractor will actually be the one to bring the documents to the building department when the time comes to get a permit, but it is the owner's responsibility to be aware of what the rules are.

Co-ops and condos have in-building rules and regulations as well. These are outlined in documents that the buyers should have received prior to purchasing a unit, so that the buyers and their consultants can review them before going through with the transaction. Co-op and condo rules vary widely, but they always describe how an owner gets permission to do home improvements. Once the procedure is understood, it is best to consult with the person who will be reviewing and administering the project's compliance with the rules. Be sure to get a summary of the requirements for your contractor so that when you are ready to interview potential contractors, you can be certain they are able and willing to satisfy the requirements. For example, condo and co-op organizations often have insurance requirements, qualifications for the workers, and expectations about the hours and days in which the work can take place. Recently, many apartment buildings have been imposing an overall time limit on the construction. If the project exceeds that time period, the owner must pay the building a penalty for each day beyond the limit.

 If a project is under construction when the local government changes the setback ordinance, the homeowner's right to build to the original setback dimensions will be protected. The earlier standard will be "grandfathered" in, meaning that the old rules will continue to apply to the property.

Urban centers often have busy building departments, and it can be difficult to maneuver through them for advice. Fortunately, in the largest cities there generally are specialists available for hire, who help clients, their architects, and their contractors through the building department regulations and approval processes. These consultants are often known as expediters or code consultants. When considering buying an urban property to serve as a residence, such as a loft, it may be worthwhile to pay a code consultant to investigate the matter. Sometimes a space cannot be legally used as a residence, even though the previous owner lived there.

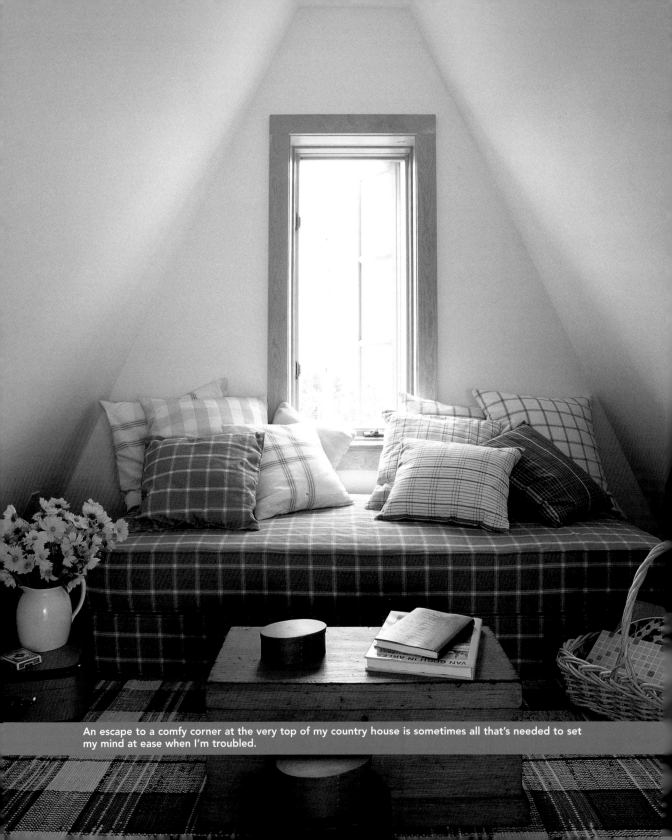

An escape to a comfy corner at the very top of my country house is sometimes all that's needed to set my mind at ease when I'm troubled.

By now it must be evident that achieving the dream home is one of the toughest challenges a family can take on. Long ago, people rarely bought more than one home in a lifetime. They spent time improving and transforming the home, bringing it closer to their dreams, with the hope of passing it down to their children. Modern times, as a general rule, do not afford the luxury of staying rooted in one place. But when circumstances do permit homeowners to devote the time, effort, and money to improving a home, it can be one of the most rewarding investments of their entire life.

It is a well-known fact that home improvement is contagious. I remember living in a small apartment in a rundown neighborhood, where I took it upon myself to re-landscape the narrow lot behind the building. The neighboring yards

Step 20

Keeping the Faith

Remember that a dream home will take time, patience, and hard work; but it is a proven financial and emotional investment.

had not been touched for decades, yet within two years of my work the entire block sprouted new gardens. Statistics prove that a person's home will be one of his or her most profitable assets, if the house and the neighborhood are well maintained or improved. Conversely, when the home and the neighborhood are not cared for, the property owners will lose, both in their prospects for living better and in diminished returns on their life savings.

An important thing to remember is that the dream home does not need to be accomplished all at once. A good home can be a place where just one corner is exactly the way you want it to be. The dream home can even be a place you carry in your head, refining it as you see new examples of things you admire and as you think of new ways to express yourself. If and when you're ready to make the move toward creating your dream

⊞ THE GOOD HOME DIARY ⊞

KEEP A JOURNAL

You can discover the nature of your personal dream home by paying close attention to what it is that makes life most pleasant for you. Keeping a journal of what makes you happy in your home over the course of a day, a week, and a season will help you discover the dream home within. Here is a sample.

	WORK WEEK	SATURDAY	SUNDAY	HOLIDAY
FALL				
Morning	Long hot showers			
Afternoon			Watching the game	
Evening				Thanksgiving dinner
WINTER				
Morning				
Afternoon			Quilting parties	
Evening	Early dinners			Late-night parties
SPRING				
Morning			Spring cleaning	
Afternoon	Helping kids with homework			
Evening				
SUMMER				
Morning				
Afternoon		Fixing up the car		
Evening				Family stay-overs

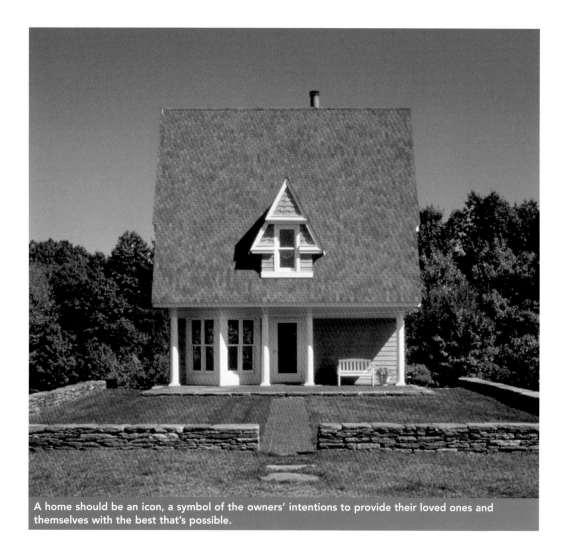

A home should be an icon, a symbol of the owners' intentions to provide their loved ones and themselves with the best that's possible.

home, never doubt that you are making a worthwhile effort. Achieving a good home is one of life's greatest accomplishments, one that will make a tangible difference for you, your loved ones, and your community. Tremendous joy springs from good house hunting and dream home planning. Few things are more satisfying than acting on the belief that you can someday live in a home that represents your fondest wishes. Keeping that faith can inspire diligence, harmony, and creative thinking.

Achieving a good home is one of life's greatest accomplishments.

INDEX